IN VASARI'S LIFE OF LEONARDO DA VINCI as we now read it there are some variations from the first edition.[1] There, the painter who has fixed the outward type of Christ for succeeding centuries was a bold speculator, holding lightly by other men's beliefs, setting philosophy above Christianity. Words of his, trenchant enough to justify this impression, are not recorded, and would have been out of keeping with a genius of which one characteristic is the tendency to lose itself in a refined and graceful mystery. The suspicion was but the time-honoured mode in which the world stamps its appreciation of one who has thoughts for himself alone, his high indifference, his intolerance of the common form of things; and in the second edition the image was changed into something fainter and more conventional. But it is still by a certain mystery in his work, and something enigmatical beyond the usual measure of great men, that he fascinates, or perhaps half repels. His life is one of sudden revolts, with intervals in which he works not at all, or apart from the main scope of his work. By a strange fortune the works on which his more popular fame rested disappeared early from the world, as the *Battle of the Standard*; or are mixed obscurely with the work of meaner hands, as the *Last Supper*.[2] His type of beauty is so exotic that it fascinates a larger number than it delights, and seems more than that of any other artist to reflect ideas and views and some scheme of the world within; so that he seemed to his contemporaries to be the possessor of some unsanctified and secret wisdom; as to Michelet and others to have anticipated modern ideas. He trifles with his genius, and crowds all his chief work into a few tormented years of later life; yet he is so possessed by his genius that he passes unmoved through the most tragic events, overwhelming his country and friends, like one who comes across them by chance on some secret errand.

His *legend*, as the French say, with the anecdotes which every one knows, is one of the most brilliant in Vasari. Later writers merely copied it, until, in 1804, Carlo Amoretti applied to it a criticism which left hardly a date fixed, and not one of those anecdotes untouched. The various questions thus raised have since that time become, one after another, subjects of special study, and mere antiquarianism has in this direction little more to do. For others remain the editing of the thirteen books of his manuscripts, and the separation by technical criticism of what in his reputed works is really his, from what is only half his, or the work of his pupils. But a lover of strange souls may still analyse for himself the impression made on him by those works, and try to reach through it a definition of the chief elements of Leonardo's genius. The *legend*, corrected and enlarged by its critics, may now and then intervene to support the results of this analysis.

His life has three divisions – thirty years at Florence, nearly twenty years at Milan, then nineteen years of wandering, till he sinks to rest under the protection of Francis the First at the *Château de Clou*.[3] The dishonour of illegitimacy hangs over his birth. Piero Antonio, his father, was of a noble Florentine house, of Vinci in the *Val d'Arno*, and Leonardo, brought up delicately among the true children of that house, was the love-child of his youth, with the keen, puissant nature such children often have. We see him in his youth fascinating all men by his beauty, improvising music and songs, buying the caged birds and setting them free, as he walked the streets of Florence, fond of odd bright dresses and spirited horses.

From his earliest years he designed many objects, and constructed models in relief, of which Vasari mentions some of women smiling. His father, pondering over this promise in the child, took him to the workshop of Andrea del Verrocchio, then the

most famous artist in Florence. Beautiful objects lay about there – reliquaries, pyxes, silver images for the pope's chapel at Rome, strange fancy-work of the middle age, keeping odd company with fragments of antiquity, then but lately discovered. Another student Leonardo may have seen there – a boy into whose soul the level light and aërial illusions of Italian sunsets had passed, in after days famous as Perugino. Verrocchio was an artist of the earlier Florentine type, carver, painter, and worker in metals, in one; designer, not of pictures only, but of all things for sacred or household use, drinking-vessels, ambries, instruments of music, making them all fair to look upon, filling the common ways of life with the reflexion of some far-off brightness; and years of patience had refined his hand till his work was now sought after from distant places.

It happened that Verrocchio was employed by the brethren of Vallombrosa to paint the *Baptism of Christ*, and Leonardo was allowed to finish an angel in the left-hand corner.[4] It was one of those moments in which the progress of a great thing – here, that of the art of Italy – presses hard and sharp on the happiness of an individual, through whose discouragement and decrease, humanity, in more fortunate persons, comes a step nearer to its final success.

For beneath the cheerful exterior of the mere well-paid craftsman, chasing brooches for the copes of Santa Maria Novella, or twisting metal screens for the tombs of the Medici, lay the ambitious desire of expanding the destiny of Italian art by a larger knowledge and insight into things, a purpose in art not unlike Leonardo's still unconscious purpose; and often, in the modelling of drapery, or of a lifted arm, or of hair cast back from the face, there came to him something of the freer manner and richer humanity of a later age. But in this *Baptism* the pupil had surpassed the master; and Verrocchio turned away as one stunned, and as if his sweet earlier work must thereafter be distasteful to him, from the bright animated angel of Leonardo's hand.

The angel may still be seen in Florence, a space of sunlight in the cold, laboured old picture; but the legend is true only in sentiment, for painting had always been the art by which Verrocchio set least store. And as in a sense he anticipates Leonardo, so to the last Leonardo recalls the studio of Verrocchio, in the love of beautiful toys, such as the vessel of water for a mirror, and lovely needlework about the implicated hands in the *Modesty and Vanity*, and of reliefs, like those cameos which in the *Virgin of the Balances* hang all round the girdle of Saint Michael,[5] and of bright variegated stones, such as the agates in the *Saint Anne*,[6] and in a hieratic preciseness and grace, as of a sanctuary swept and garnished. Amid all the cunning and intricacy of his Lombard manner this never left him. Much of it there must have been in that lost picture of *Paradise*, which he prepared as a cartoon for tapestry, to be woven in the looms of Flanders. It was the perfection of the older Florentine style of miniature-painting, with patient putting of each leaf upon the trees and each flower in the grass, where the first man and woman were standing.

And because it was the perfection of that style, it awoke in Leonardo some seed of discontent which lay in the secret places of his nature. For the way to perfection is through a series of disgusts; and this picture – all that he had done so far in his life at Florence – was after all in the old slight manner. His art, if it was to be something in the world, must be weighted with more of the meaning of nature and purpose of humanity. Nature was 'the true mistress of higher intelligences'. So he plunged into the study of nature. And in doing this he followed the manner of the older students; he brooded over the hidden virtues of plants and crystals, the lines traced by the stars as they moved in the sky, over the correspondences which exist between the different orders of living things, through which, to eyes opened, they interpret each other; and for years he seemed to those about him as one listening to a voice silent for other men.

He learned here the art of going deep, of tracking the sources of expression to their subtlest retreats, the power of an intimate presence in the things he handled. He did

not at once entirely desert his art; only he was no longer the cheerful, objective painter, through whose soul, as through clear glass, the bright figures of Florentine life, only made a little mellower and more pensive by the transit, passed on to the white wall. He wasted many days in curious tricks of design, seeming to lose himself in the spinning of intricate devices of lines and colours. He was smitten with a love of the impossible – the perforation of mountains, changing the course of rivers, raising great buildings, such as the church of San Giovanni, in the air; all those feats for the performance of which natural magic professes to have the key. Later writers, indeed, see in these efforts an anticipation of modern mechanics; in him they were rather dreams, thrown off by the overwrought and labouring brain. Two ideas were especially fixed in him, as reflexes of things that had touched his brain in childhood beyond the measure of other impressions – the smiling of women and the motion of great waters.[7]

And in such studies some interfusion of the extremes of beauty and terror shaped itself, as an image that might be seen and touched, in the mind of this gracious youth, so fixed that for the rest of his life it never left him. As if catching glimpses of it in the strange eyes or hair of chance people, he would follow such about the streets of Florence till the sun went down, of whom many sketches of his remain. Some of these are full of a curious beauty, that remote beauty apprehended only by those who have sought it carefully; who, starting with acknowledged types of beauty, have refined as far upon these, as these refine upon the world of common forms. But mingled inextricably with this there is an element of mockery also; so that, whether in sorrow or scorn, he caricatures Dante even. Legions of grotesques sweep under his hand; for has not nature too her grotesques – the rent rock, the distorting light of evening on lonely roads, the unveiled structure of man in the embryo, or the skeleton?

All these swarming fancies unite in the *Medusa* of the *Uffizi*.[8] Vasari's story of an earlier Medusa, painted on a wooden shield, is perhaps an invention; and yet, properly told, has more of the air of truth about it than anything else in the whole legend. For its real subject is not the serious work of a man, but the experiment of a child. The lizards and glowworms and other strange small creatures which haunt an Italian vineyard bring before one the whole picture of a child's life in a Tuscan dwelling, half castle, half farm; and are as true to nature as the pretended astonishment of the father for whom the boy has prepared a surprise. It was not in play that he painted that other Medusa, the one great picture which he left behind him in Florence. The subject has been treated in various ways; Leonardo alone cuts to its centre; he alone realizes it as the head of a corpse, exercising its powers through all the circumstances of death. What may be called the fascination of corruption penetrates in every touch its exquisitely finished beauty. About the dainty lines of the cheek the bat flits unheeded. The delicate snakes seem literally strangling each other in terrified struggle to escape from the Medusa brain. The hue which violent death always brings with it is in the features: features singularly massive and grand, as we catch them inverted, in a dexterous foreshortening, sloping upwards, almost sliding down upon us, crown foremost, like a great calm stone against which the wave of serpents breaks. But it is a subject that may well be left to the beautiful verses of Shelley.

The science of that age was all divination, clairvoyance, unsubjected to our exact modern formulas, seeking in an instant of vision to concentrate a thousand experiences. Later writers, thinking only of the well-ordered treatise on painting which a Frenchman, Raphaël du Fresne, a hundred years afterwards, compiled from Leonardo's bewildered manuscripts, written strangely, as his manner was, from right to left, have imagined a rigid order in his inquiries.[9] But this rigid order was little in accordance with the restlessness of his character; and if we think of him as the mere reasoner who subjects design to anatomy, and composition to mathematical rules, we shall hardly have of him that impression which those about him received from him. Poring over his

crucibles, making experiments with colour, trying by a strange variation of the alchemist's dream to discover the secret, not of an elixir to make man's natural life immortal, but rather of giving immortality to the subtlest and most delicate effects of painting, he seemed to them rather the sorcerer or the magician, possessed of curious secrets and a hidden knowledge, living in a world of which he alone possessed the key. What his philosophy seems to have been most like is that of Paracelsus or Cardan; and much of the spirit of the older alchemy still hangs about it, with its confidence in short cuts and odd byways to knowledge. To him philosophy was to be something giving strange swiftness and double sight, divining the sources of springs beneath the earth or of expression beneath the human countenance, clairvoyant of occult gifts in common or uncommon things, in the reed at the brook-side, or the star which draws near to us but once in a century. How, in this way, the clear purpose was overclouded, the fine chaser's hand perplexed, we but dimly see; the mystery which at no point quite lifts from Leonardo's life is deepest here. But it is certain that at one period of his life he had almost ceased to be an artist.

The year 1483 – the year of the birth of Raphael and the thirty-first of Leonardo's life – is fixed as the date of his visit to Milan by the letter in which he recommends himself to Ludovico Sforza, and offers to tell him, for a price, strange secrets in the art of war. It was that Sforza who murdered his young nephew by slow poison, yet was so susceptible of religious impressions that he blended mere earthly passions with a sort of religious sentimentalism, and who took for his device the mulberry tree – symbol, in its long delay and sudden yielding of flowers and fruit together, of a wisdom which economizes all forces for an opportunity of sudden and sure effect. The fame of Leonardo had gone before him, and he was to model a colossal statue of Francesco, the first duke of Milan.[10] As for Leonardo himself, he came not as an artist at all, or careful of the fame of one; but as a player on the harp, a strange harp of silver of his own construction, shaped in some curious likeness to a horse's skull. The capricious spirit of Ludovico was susceptible also of the charm of music, and Leonardo's nature had a kind of spell in it. Fascination is always the word descriptive of him. No portrait of his youth remains; but all tends to make us believe that up to this time some charm of voice and aspect, strong enough to balance the disadvantage of his birth, had played about him. His physical strength was great; it was said that he could bend a horseshoe like a coil of lead.

The *Duomo*, the work of artists from beyond the Alps, so fantastic to the eye of a Florentine, used to the mellow, unbroken surfaces of Giotto and Arnolfo, was then in all its freshness; and below, in the streets of Milan, moved a people as fantastic, changeful, and dreamlike. To Leonardo least of all men could there be anything poisonous in the exotic flowers of sentiment which grew there. It was a life of brilliant sins and exquisite amusements – Leonardo became a celebrated designer of pageants[11] – and it suited the quality of his genius, composed in almost equal parts of curiosity and the desire of beauty, to take things as they came.

Curiosity and the desire of beauty – these are the two elementary forces in Leonardo's genius; curiosity often in conflict with the desire of beauty, but generating, in union with it, a type of subtle and curious grace.

The movement of the fifteenth century was twofold; partly the Renaissance, partly also the coming of what is called the 'modern spirit', with its realism, its appeal to experience. It comprehended a return to antiquity, and a return to nature. Raphael represents the return to antiquity, and Leonardo the return to nature. In this return to nature, he was seeking to satisfy a boundless curiosity by her perpetual surprises, a microscopic sense of finish by her *finesse*, or delicacy of operation, that *subtilitas naturæ* which Bacon notices. So we find him often in intimate relations with men of science, with Fra Luca Pacioli the mathematician, and the anatomist Marc Antonio della

Torre. His observations and experiments fill thirteen volumes of manuscript;[12] and those who can judge describe him as anticipating long before, by rapid intuition, the later ideas of science. He explained the obscure light of the unilluminated part of the moon, knew that the sea had once covered the mountains which contain shells, and of the gathering of the equatorial waters above the polar.

He who thus penetrated into the most secret parts of nature preferred always the more to the less remote, what, seeming exceptional, was an instance of law more refined, the construction about things of a peculiar atmosphere and mixed lights. He paints flowers with such curious felicity that different writers have attributed to him a fondness for particular flowers, as Clement the cyclamen, and Rio the jasmine; while, at Venice, there is a stray leaf from his portfolio dotted all over with studies of violets and the wild rose.[13] In him first, appears the taste for what is *bizarre* or *recherché* in landscape; hollow places full of the green shadow of bituminous rocks, ridged reefs of trap-rock which cut the water into quaint sheets of light – their exact antitype is in our own western seas; all the solemn effects of moving water; you may follow it springing from its distant source among the rocks on the heath of the *Madonna of the Balances*, passing as a little fall into the treacherous calm of the *Madonna of the Lake*,[14] next, as a goodly river, below the cliffs of the *Madonna of the Rocks*, washing the white walls of its distant villages, stealing out in a network of divided streams in *La Gioconda* to the sea-shore of the *Saint Anne* – that delicate place where the wind passes like the hand of some fine etcher over the surface, and the unworn shells are lying thick upon the sand, and the tops of the rocks, to which the waves never rise, are green with grass, grown as fine as hair. It is the landscape, not of dreams or of fancy, but of places far withdrawn, and hours selected from a thousand with a miracle of *finesse*. Through Leonardo's strange veil of sight things reach him so; in no ordinary night or day, but in faint light of eclipse, or in some brief interval of falling rain at daybreak, or through deep water.

And not into nature only; but he plunged also into human personality, and became above all a painter of portraits; faces of a modelling more skilful than has been seen before or since, embodied with a reality which almost amounts to illusion, on dark air. To take a character as it was, and delicately sound its stops, suited one so curious in observation, curious in invention. So he painted the portraits of Ludovico's mistresses, Lucretia Crivelli and Cecilia Gallerani the poetess, of Ludovico himself, and the Duchess Beatrice. The portrait of Cecilia Gallerani is lost, but that of Lucretia Crivelli has been identified with *La Belle Ferronnière* of the Louvre, and Ludovico's pale anxious face still remains in the Ambrosian library.[15] Opposite is the portrait of Beatrice d'Este, in whom Leonardo seems to have caught some presentiment of early death, painting her precise and grave, full of the refinement of the dead, in sad earth-coloured raiment, set with pale stones.

Sometimes this curiosity came in conflict with the desire of beauty; it tended to make him go too far below that outside of things in which art begins and ends. This struggle between the reason and its ideas, and the senses, the desire of beauty, is the key to Leonardo's life at Milan – his restlessness, his endless re-touchings, his odd experiments with colour. How much must he leave unfinished, how much recommence! His problem was the transmutation of ideas into images. What he had attained so far had been the mastery of that earlier Florentine style, with its naive and limited sensuousness. Now he was to entertain in this narrow medium those divinations of a humanity too wide for it, that larger vision of the opening world, which is only not too much for the great, irregular art of Shakespeare; and everywhere the effort is visible in the work of his hands. This agitation, this perpetual delay, give him an air of weariness and *ennui*. To others he seems to be aiming at an impossible effect, to do something that art, that painting, can never do. Often the expression of physical beauty at this or that point seems strained

and marred in the effort, as in those heavy German foreheads – too heavy and German for perfect beauty.

For there was a touch of Germany in that genius which, as Goethe said, had *müde sich gedacht*, 'thought itself weary'. What an anticipation of modern Germany, for instance, in that debate on the question whether sculpture or painting is the nobler art.* But there is this difference between him and the German, that, with all that curious science, the German would have thought nothing more was needed; and the name of Goethe himself reminds one how great for the artist may be the danger of over-much science; how Goethe, who, in the *Elective Affinities* and the first part of *Faust*, does transmute ideas into images, who wrought many such transmutations, did not invariably find the spell-word, and in the second part of *Faust* presents us with a mass of science which has almost no artistic character at all. But Leonardo will never work till the happy moment comes – that moment of *bien-être*, which to imaginative men is a moment of invention. On this moment he waits; other moments are but a preparation, or after-taste of it. Few men distinguish between them as jealously as he did. Hence, so many flaws even in the choicest work. But for Leonardo the distinction is absolute, and, in the moment of *bien-être*, the alchemy complete; the idea is stricken into colour and imagery; a cloudy mysticism is refined to a subdued and graceful mystery, and painting pleases the eye while it satisfies the soul.

This curious beauty is seen above all in his drawings, and in these chiefly in the abstract grace of the bounding lines. Let us take some of these drawings,[16] and pause over them awhile; and, first, one of those at Florence – the heads of a woman and a little child, set side by side, but each in its own separate frame. First of all, there is much pathos in the re-appearance in the fuller curves of the face of the child, of the sharper, more chastened lines of the worn and older face, which leaves no doubt that the heads are those of a little child and its mother. A feeling for maternity is indeed always character-istic of Leonardo; and this feeling is further indicated here by the half-humorous pathos of the diminutive, rounded shoulders of the child. You may note a like pathetic power in drawings of a young man, seated in a stooping posture, his face in his hands, as in sorrow; of a slave sitting in an uneasy inclined posture, in some brief interval of rest; of a small Madonna and Child, peeping sideways in a half-reassured terror, as a mighty griffin with bat-like wings, one of Leonardo's finest *inventions*, descends suddenly from the air to snatch up a lion wandering near them. But note in these, as that which especially belongs to art, the contour of the young man's hair, the poise of the slave's arm above his head, and the curves of the head of the child, following the little skull within, thin and fine as some sea-shell worn by the wind.

Take again another head, still more full of sentiment, but of a different kind, a little drawing in red chalk which every one remembers who has examined at all carefully the drawings by old masters at the Louvre. It is a face of doubtful sex, set in the shadow of its own hair, the cheek-line in high light against it, with something voluptuous and full in the eyelids and the lips. Another drawing might pass for the same face in childhood, with parched and feverish lips, but with much sweetness in the loose, short-waisted childish dress, with necklace and *bulla*, and in the daintily bound hair. We might take the thread of suggestion which these two drawings offer, when thus set side by side, and, following it through the drawings at Florence, Venice, and Milan, construct a sort of series, illustrating better than anything else Leonardo's type of womanly beauty. Daughters of Herodias, with their fantastic head-dresses knotted and folded so strangely, to leave the dainty oval of the face disengaged,[17] they are not of the Christian family, or of Raphael's. They are the clairvoyants, through whom, as through delicate instru-ments, one becomes aware of the subtler forces of nature, and the modes of their action,

*How princely, how characteristic of Leonardo, the answer, *Quanto più un' arte porta seco fatica di corpo, tanto più è vile!* [The more physical effort an art requires, the more ignoble is it.]

all that is magnetic in it, all those finer conditions wherein material things rise to that subtlety of operation which constitutes them spiritual, where only the finer nerve and the keener touch can follow; it is as if in certain revealing instances we actually saw them at their work on human flesh. Nervous, electric, faint always with some inexplicable faintness, they seem to be subject to exceptional conditions, to feel powers at work in the common air unfelt by others, to become, as it were, receptacles of them, and pass them on to us in a chain of secret influences.

But among the more youthful heads there is one at Florence, which Love chooses for its own – the head of a young man, which may well be the likeness of Andrea Salaino, beloved of Leonardo for his curled and waving hair – *belli capelli ricci e inanellati* – and afterwards his favourite pupil and servant.[18] Of all the interests in living men and women which may have filled his life at Milan, this attachment alone is recorded; and in return, Salaino identified himself so entirely with Leonardo, that the picture of *Saint Anne*, in the Louvre, has been attributed to him. It illustrates Leonardo's usual choice of pupils, men of some natural charm of person or intercourse like Salaino, or men of birth and princely habits of life like Francesco Melzi – men with just enough genius to be capable of initiation into his secret, for the sake of which they were ready to efface their own individuality. Among them, retiring often to the villa of the Melzi at Canonica al Vaprio, he worked at his fugitive manuscripts and sketches, working for the present hour, and for a few only, perhaps chiefly for himself. Other artists have been as careless of present or future applause, in self-forgetfulness, or because they set moral or political ends above the ends of art; but in him this solitary culture of beauty seems to have hung upon a kind of self-love, and a carelessness in the work of art of all but art itself. Out of the secret places of a unique temperament he brought strange blossoms and fruits hitherto unknown; and for him, the novel impression conveyed, the exquisite effect woven, counted as an end in itself – a perfect end.

And these pupils of his acquired his manner so thoroughly that, though the number of Leonardo's authentic works is very small indeed, there is a multitude of other men's pictures through which we undoubtedly see him, and come very near to his genius. Sometimes, as in the little picture of the *Madonna of the Balances*, in which, from the bosom of his mother, Christ is weighing the pebbles of the brook against the sins of men, we have a hand, rough enough by contrast, working upon some fine hint or sketch of his. Sometimes, as in the subjects of the *Daughter of Herodias* and the *Head of John the Baptist*, the lost originals have been re-echoed and varied upon again and again by Luini and others. At other times the original remains, but has been a mere theme or motive, a type of which the accessories might be modified or changed; and these variations have but brought out the more the purpose, or expression of the original. It is so with the so-called *Saint John the Baptist* of the Louvre[19] – one of the few naked figures Leonardo painted – whose delicate brown flesh and woman's hair no one would go out into the wilderness to seek, and whose treacherous smile would have us understand something far beyond the outward gesture, or circumstance. But the long, reed-like cross in the hand, which suggests Saint John the Baptist, becomes faint in a copy at the Ambrosian Library, and disappears altogether in another, in the Palazzo Rosso at Genoa. Returning from the last to the original, we are no longer surprised by Saint John's strange likeness to the *Bacchus* which hangs near it,[20] which set Théophile Gautier thinking of Heine's notion of decayed gods, who, to maintain themselves, after the fall of paganism, took employment in the new religion. We recognize one of those symbolical inventions in which the ostensible subject is used, not as matter for definite pictorial realization, but as the starting-point of a train of sentiment, as subtle and vague as a piece of music. No one ever ruled over his subject more entirely than Leonardo, or bent it more dexterously to purely artistic ends. And so it comes to pass that, though he handles sacred subjects continually, he is the most profane of painters;

the given person or subject, Saint John in the Desert, or the Virgin on the knees of Saint Anne, is often merely the pretext for a kind of work which carries one quite out of the range of its conventional associations.

About the *Last Supper*,[21] its decay and restorations, a whole literature has risen up, Goethe's pensive sketch of its sad fortunes being far the best. The death in child-birth of the Duchess Beatrice was followed in Ludovico by one of those paroxysms of religious feeling which in him were constitutional. The low, gloomy Dominican church of *Saint Mary of the Graces* had been the favourite shrine of Beatrice. She had spent her last days there, full of sinister presentiments; at last it had been almost necessary to remove her from it by force; and now it was here that Mass was said a hundred times a day for her repose. On the damp wall of the refectory, oozing with mineral salts, Leonardo painted the *Last Supper*. A hundred anecdotes were told about it, his retouchings and delays. They show him refusing to work except at the moment of invention, scornful of whoever thought that art was a work of mere industry and rule, often coming the whole length of Milan to give a single touch. He painted it, not in fresco, where all must be *impromptu*, but in oils, the new method which he had been one of the first to welcome, because it allowed of so many after-thoughts, so refined a working out of perfection. It turned out that on a plastered wall no process could have been less durable. Within fifty years it had fallen into decay. And now we have to turn back to Leonardo's own studies,[22] above all, to one drawing of the central head at the Brera, which, in a union of tenderness and severity in the face-lines, reminds one of the monumental work of Mino da Fiesole, to trace it as it was.

It was another effort to set a given subject out of the range of its conventional associations. Strange, after all the misrepresentations of the middle age, was the effort to see the Eucharist, not as the pale Host of the altar, but as one taking leave of his friends. Five years afterwards, the young Raphael, at Florence, painted it with sweet and solemn effect in the refectory of Saint Onofrio; but still with all the mystical unreality of the school of Perugino.[23] Vasari pretends that the central head[24] was never finished; but finished or unfinished, or owing part of its effect to a mellowing decay, the head of Jesus does but consummate the sentiment of the whole company – ghosts through which you see the wall, faint as the shadows of the leaves upon the wall on autumn afternoons – this figure is but the faintest, most spectral of them all.

The *Last Supper* was finished in 1497; in 1498 the French entered Milan, and whether or not the Gascon bowmen used it as a mark for their arrows, the model of Francesco Sforza certainly did not survive. What, in that age, such work was capable of being, of what nobility, amid what racy truthfulness to fact, we may judge from the bronze statue of Bartolomeo Colleoni on horseback, modelled by Leonardo's master, Verrocchio – he died of grief, it was said, because, the mould accidentally failing, he was unable himself to complete it – still standing in the *piazza* of Saint John and Saint Paul at Venice. Some traces of the thing may remain in certain of Leonardo's drawings,[25] and also, perhaps, by a singular circumstance, in a far-off town of France. For Ludovico became a prisoner, and ended his days at Loches in Touraine; allowed, it is said, at last to breathe fresher air for awhile in one of the rooms of a high tower there, after many years of captivity in the dungeons below, where all seems sick with barbarous feudal memories, and where his prison is still shown, its walls covered with strange painted arabesques, ascribed by tradition to his hand, amused a little thus through the tedious years – vast helmets and faces and pieces of armour, among which in great letters the motto *Infelix Sum* is woven in and out, and in which perhaps it is not too fanciful to see the fruit of a wistful after-dreaming over all those experiments with Leonardo on the armed figure of the great duke, which had occupied the two so often, during the days of his fortune at Milan.

The remaining years of Leonardo's life are more or less years of wandering. From his

brilliant life at court he had saved nothing, and he returned to Florence a poor man. Perhaps necessity kept his spirit excited: the next four years are one prolonged rapture or ecstasy of invention. He painted the pictures of the Louvre, his most authentic works which came there straight from the cabinet of Francis the First, at Fontainebleau. One picture of his, the *Saint Anne* – not the *Saint Anne* of the Louvre, but a mere cartoon, now in London – revived for a moment a sort of appreciation more common in an earlier time, when good pictures had still seemed miraculous; and for two days a crowd of people of all qualities passed in naive excitement through the chamber where it hung, and gave Leonardo a taste of Cimabue's triumph.[26] But his work was less with the saints than with the living women of Florence; for he lived still in the polished society that he loved, and in the houses of Florence, left perhaps a little subject to light thoughts by the death of Savonarola (the latest gossip is of an undraped Mona Lisa, found in some out-of-the-way corner of the late *Orléans* collection), he saw Ginevra dei Benci,[27] and Lisa, the young third wife of Francesco del Giocondo. As we have seen him using incidents of the sacred legend, not for their own sake, or as mere subjects for pictorial realization, but as a symbolical language for fancies all his own, so now he found a vent for his thoughts in taking one of these languid women, and raising her, as Leda or Pomona, Modesty or Vanity, to the seventh heaven of symbolical expression.

La Gioconda is, in the truest sense, Leonardo's masterpiece, the revealing instance of his mode of thought and work.[28] In suggestiveness, only the *Melancholia* of Dürer is comparable to it; and no crude symbolism disturbs the effect of its subdued and graceful mystery. We all know the face and hands of the figure, set in its marble chair, in that cirque of fantastic rocks, as in some faint light under sea. Perhaps of all ancient pictures time has chilled it least.* As often happens with works in which invention seems to reach its limit, there is an element in it given to, not invented by, the master. In that inestimable folio of drawings, once in the possession of Vasari, were certain designs by Verrocchio, faces of such impressive beauty that Leonardo in his boyhood copied them many times. It is hard not to connect with these designs of the elder, by-past master, as with its germinal principle, the unfathomable smile, always with a touch of something sinister in it, which plays over all Leonardo's work. Besides, the picture is a portrait. From childhood we see this image defining itself on the fabric of his dreams; and but for express historical testimony, we might fancy that this was but his ideal lady, embodied and beheld at last. What was the relationship of a living Florentine to this creature of his thought? By means of what strange affinities had the person and the dream grown up thus apart, and yet so closely together? Present from the first, incorporeal in Leonardo's thought, dimly traced in the designs of Verrocchio, she is found present at last in *Il Giocondo's* house. That there is much of mere portraiture in the picture is attested by the legend that by artificial means, the presence of mimes and flute-players, that subtle expression was protracted on the face. Again, was it in four years, and by renewed labour never really completed, or in four months, and as by stroke of magic, that the image was projected?

The presence that thus rose so strangely beside the waters, is expressive of what in the ways of a thousand years man had come to desire. Hers is the head upon which all 'the ends of the world are come', and the eyelids are a little weary. It is a beauty wrought out from within upon the flesh, the deposit, little cell by cell, of strange thoughts and fantastic reveries and exquisite passions. Set it for a moment beside one of those white Greek goddesses or beautiful women of antiquity, and how would they be troubled by this beauty, into which the soul with all its maladies has passed? All the thoughts and experience of the world have etched and moulded there, in that which they have of power to refine and make expressive the outward form, the animalism of Greece, the lust of Rome, the reverie of the middle age with its spiritual ambition and imaginative

* Yet for Vasari there was some further magic of crimson in the lips and cheeks, lost for us.

loves, the return of the Pagan world, the sins of the Borgias. She is older than the rocks among which she sits; like the vampire, she has been dead many times, and learned the secrets of the grave; and has been a diver in deep seas, and keeps their fallen day about her, and trafficked for strange webs with Eastern merchants; and, as Leda, was the mother of Helen of Troy, and, as Saint Anne, the mother of Mary; and all this has been to her but as the sound of lyres and flutes, and lives only in the delicacy with which it has moulded the changing lineaments, and tinged the eyelids and the hands. The fancy of a perpetual life, sweeping together ten thousand experiences, is an old one; and modern thought has conceived the idea of humanity as wrought upon by, and summing up in itself, all modes of thought and life. Certainly Lady Lisa might stand as the embodiment of the old fancy, the symbol of the modern idea.

During these years at Florence Leonardo's history is the history of his art; he himself is lost in the bright cloud of it. The outward history begins again in 1502, with a wild journey through central Italy, which he makes as the chief engineer of Cæsar Borgia. The biographer, putting together the stray jottings of his manuscripts, may follow him through every day of it, up the strange tower of Siena, which looks towards Rome, elastic like a bent bow, down to the sea-shore at Piombino, each place appearing as fitfully as in a fever dream.

One other great work was left for him to do, a work all trace of which soon vanished, *The Battle of the Standard,* in which he had Michelangelo for his rival. The citizens of Florence, desiring to decorate the walls of the great council-chamber, had offered the work for competition, and any subject might be chosen from the Florentine wars of the fifteenth century. Michelangelo chose for his cartoon an incident of the war with Pisa, in which the Florentine soldiers, bathing in the Arno, are surprised by the sound of trumpets, and run to arms. His design has reached us only in an old engraving, which perhaps helps us less than what we remember of the background of his *Holy Family* in the *Uffizi* to imagine in what superhuman form, such as might have beguiled the heart of an earlier world, those figures may have risen from the water. Leonardo chose an incident from the battle of Anghiari, in which two parties of soldiers fight for a standard. Like Michelangelo's, his cartoon is lost, and has come to us only in sketches, and in a fragment of Rubens. Through the accounts given we may discern some lust of terrible things in it, so that even the horses tore each other with their teeth; and yet one fragment of it, in a drawing of his at Florence,[29] is far different – a waving field of lovely armour, the chased edgings running like lines of sunlight from side to side. Michelangelo was twenty-seven years old; Leonardo more than fifty; and Raphael, then nineteen years old, visiting Florence for the first time, came and watched them as they worked.

We catch a glimpse of him again, at Rome in 1514, surrounded by his mirrors and vials and furnaces, making strange toys that seemed alive of wax and quicksilver. The hesitation which had haunted him all through life, and made him like one under a spell, was upon him now with double force. No one had ever carried political indifferentism farther; it had always been his philosophy to 'fly before the storm'; he is for the Sforzas, or against them, as the tide of their fortune turns. Yet now in the political society of Rome, he came to be suspected of concealed French sympathies. It paralysed him to find himself among enemies; and he turned wholly to France, which had long courted him.

France was about to become an Italy more Italian than Italy itself. Francis the First, like Lewis the Twelfth before him, was attracted by the *finesse* of Leonardo's work; *La Gioconda* was already in his cabinet, and he offered Leonardo the little *Château de Clou,* with its vineyards and meadows, in the pleasant valley of the Masse, just outside the walls of the town of Amboise, where, especially in the hunting season, the court then frequently resided. *A Monsieur Lyonard, peinteur du Roy pour Amboyse* – so the letter of Francis the First is headed. It opens a prospect, one of the most attractive in

the history of art, where, under a strange mixture of lights, Italian art dies away as a French exotic.

Two questions remain, after much busy antiquarianism, concerning Leonardo's death – the question of the form of his religion, and the question whether Francis the First was present at the time. They are of about equally little importance in the estimate of Leonardo's genius. The directions in his will about the thirty Masses and the great candles for the church of Saint Florentin are things of course, their real purpose being immediate and practical; and on no theory of religion could these hurried offices be of much consequence. We forget them in speculating how one who had been always so desirous of beauty, but desired it always in such definite and precise forms as hands or flowers or hair, looked forward now into the vague land, and experienced the last curiosity.

THE ESSAY on Leonardo, the first of Walter Pater's studies of artists and writers of the Renaissance, was written in 1869, when the author was thirty years old. Kenneth Clark, in his edition of Pater's essays (*The Renaissance, Studies in Art and Poetry,* Fontana Library, Collins, 1961), calls it the most effective and memorable of all Pater's essays. 'Even today,' he continues, 'with access to Leonardo's notebooks and to a vast corpus of scholarship, we cannot improve on Pater's characterization, and the too familiar description of the Mona Lisa . . . remains, if read in its context, a defensible interpretation . . . The chief cause for regret is that he did not know Leonardo's original drawings. The great collection at Windsor Castle was almost unknown till a part of it was exhibited in the Grosvenor Gallery in 1878.'

Where Pater speaks of paintings and drawings which are no longer accepted as by Leonardo, this is pointed out in the following notes.

Brief Bibliography

André Chastel, *The Genius of Leonardo da Vinci, Leonardo da Vinci on Art and the Artist.* New York, 1961.

Kenneth Clark, *Leonardo da Vinci, an Account of his Development as an Artist.* Cambridge, 1952 (first published in 1939). Penguin 1958.

Kenneth Clark, *The Drawings of Leonardo da Vinci in the Collection of Her Majesty The Queen.* First edition 1935. Second edition, revised with the assistance of Carlo Pedretti, London and New York, 1968–9.

Ludwig Goldscheider, *Leonardo da Vinci, Paintings and Drawings.* First edition 1943; eighth edition, London, 1967, reprinted 1969.

Edward MacCurdy, *The Notebooks of Leonardo da Vinci.* London, 1939; latest edition, London, 1956.

A. Philip MacMahon, *Leonardo da Vinci, Treatise on Painting,* Princeton, 1956.

A. E. Popham, *The Drawings of Leonardo da Vinci.* London, 1946; latest edition 1949.

Jean Paul Richter, *The Literary Works of Leonardo da Vinci,* London, 1883; third edition, London and New York, 1970.

Notes

1. One of our principal sources for the history of Renaissance art, Giorgio Vasari's biographies (*Vite*) of Italian artists were first published in Florence in 1550. A second, enlarged edition appeared in 1568.
2. *The Battle of the Standard:* painted in 1503–5 in the great Council Hall of the Palazzo Vecchio in Florence; see p. 12 above. – *The Last Supper:* Plates 20–2.
3. Leonardo was born at Vinci on April 15, 1452. He died at the Palace of Cloux, near Amboise on the Loire, on May 2, 1519.
4. Detail from Verrocchio's *Baptism of Christ:* Plate 1.
5. *Modesty and Vanity,* which exists in several versions, is now attributed to Bernardino Luini, a Lombard artist influenced by Leonardo. – *The Virgin of the Balances,* in the Louvre, Paris, is now believed to have been painted by Cesare da Sesto, another Lombard imitator of Leonardo's style. Pater himself implies later, on p. 9, that it is not by Leonardo.
6. *The Virgin and Child with St. Anne and the Lamb:* Plates 29–30.
7. The smiling of women: see St. Anne, Plates 28 and 30, and the portrait of Mona Lisa, Plate 27. – The motion of great waters: the famous series of ten 'Deluge' drawings in the Royal Library (see Plate 47) was not known to Pater.
8. The *Medusa* painting in the Uffizi Gallery, Florence, is not by Leonardo, but dates from the seventeenth century.
9. The most comprehensive and most accessible edition of Leonardo's writings on the arts and sciences, with translations into English, is that by Jean Paul Richter (2 vols., third edition, London and New York, 1970).

10. The equestrian monument to Francesco Sforza: see note to Plate 38.
11. See Plate 48.
12. See note 9 above.
13. See Plate 36.
14. *Madonna of the Balances:* see note 5 above. – *Madonna of the Lake:* probably painted by Marco d'Oggiono after a drawing by Leonardo; known from a nineteenth-century engraving and from a version in the Bob Jones University Gallery, Greenville, South Carolina.
15. The portrait of Cecilia Gallerani is now usually identified with the painting in Cracow, Plate 9. – *La Belle Ferronnière:* Plate 19. – The portraits of Ludovico Sforza and Beatrice d'Este are not by Leonardo.
16. The drawings described here by Pater are no longer attributed to Leonardo. Pater did not know the Leonardo drawings in the Royal Library.
17. *Daughters of Herodias:* several pictures of Salome, by Luini, were at one time believed to be by Leonardo. – Fantastic headdresses: see Plate 44.
18. Pater means Giacomo Salai, who had joined Leonardo's household in 1490 as a boy of ten years.
19. *St. John the Baptist:* Plate 31.
20. The *Bacchus* in the Louvre was painted by an imitator, possibly after a cartoon by Leonardo. The figure was originally perhaps a John Baptist and was later given the attributes of Bacchus.
21. *The Last Supper:* Plates 20–2.
22. Some of Leonardo's own studies for the Apostles in the *Last Supper* are in the Royal Library: see Plates 40 and 41.
23. The *Last Supper* in the church of S. Onofrio, Florence, is now attributed to Perugino.
24. The head of Jesus: Plate 21.
25. See note to Plate 38.
26. The surviving cartoon, formerly at Burlington House, is now in the National Gallery, London: Plate 28. But the cartoon which evoked such admiration was a different one and is no longer extant.
27. Portrait of Ginevra de' Benci: Plate 8.
28. Portrait of La Gioconda (Mona Lisa): Plate 27.
29. The drawing in Florence is not autograph, but some of Leonardo's own studies for the *Battle of Anghiari* are preserved in Budapest (Plate 42), London, Oxford, Turin, Venice and Windsor.

List of Plates

1. *Two Angels.* Detail from Verrocchio's *Baptism of Christ.* About 1472. Florence, Uffizi.
Of the two angels, only the one in profile is by Leonardo. The characteristic fall of the folds foreshadows later works such as those reproduced on Plates 5 and 24. Vasari tells us that Leonardo, while employed in Verrocchio's workshop, modelled clay figures, which he draped in soft cloths dipped in plaster, and then made drawings of these draperies.

2–4. *The Annunciation.* About 1476–8. Wood, $38\frac{1}{2} \times 85\frac{1}{2}$ in. Florence, Uffizi.
Painted while Leonardo was still a member of Verrocchio's workshop, and possibly with some help from a fellow-apprentice.

5. *Drapery Study.* Silverpoint, heightened with white, on red prepared paper, $10\frac{1}{8} \times 7\frac{5}{8}$ in. Rome, Corsini Gallery.

6. *Virgin and Child,* known as Madonna Benois. 1478–80. Wood, transferred to canvas, $19\frac{1}{2} \times 12\frac{5}{8}$ in. Leningrad, Hermitage.

7. *Virgin and Child,* known as Madonna with the Carnation. Wood, $24\frac{3}{8} \times 18\frac{3}{4}$ in. Munich, Alte Pinakothek.
The attribution to Leonardo has sometimes been disputed. He may have painted only some parts of it while working in Verrocchio's workshop.

8. *Portrait of Ginevra de' Benci.* 1478–80. Wood, $15\frac{1}{8} \times 14\frac{1}{2}$ in. Washington, D.C., National Gallery of Art.
Ginevra, born in 1457, was a member of a well-to-do, cultured Florentine family and herself a poet. At the age of sixteen she married Luigi Niccolini. A year later she fell in love with Bernardo Bembo, the father of the future Cardinal Bembo, as John Walker has described in an exhaustive study of the portrait. Her name is a dialect form of the Italian word for juniper, the bush which frames her head in the portrait. The swirling eddies of her curls recall a note which Leonardo was to write many years later: 'The motion of the surface of water resembles that of hair . . .' On the back of the panel Leonardo painted a sprig of juniper between a laurel branch (an allusion to her poetry) and a palm branch, with a scroll inscribed: virtutem forma decorat. The lower part of the picture was damaged and cut off before the nineteenth century: it probably showed Ginevra's hands – see note on Plate 34. The picture was in the collection of the Princes of Liechtenstein for close on 300 years, before it was bought by the National Gallery of Art in 1967.

9. *Portrait of a Lady with an Ermine.* 1483–4. Wood, $20\frac{7}{8} \times 15\frac{1}{2}$ in. Cracow, National Museum.
The portrait was painted soon after Leonardo's arrival in Milan and is thought to represent Cecilia Gallerani, a mistress of Ludovico Sforza, the ermine (Greek: galé) being an allusion to her name. The inscription top left was added about 1800; and the background has been overpainted.

10. *St. Jerome in Penitence.* Wood, $40\frac{5}{8} \times 29\frac{1}{2}$ in. Rome, Vatican Gallery.
The picture, which is unfinished, shows the fourth-century Doctor of the Church, who is best known for his Latin translation of the Scriptures, the Vulgate. He was often depicted

as a hermit in the wilderness, beating his breast with a stone and accompanied by a lion he had tamed.

11–13. *The Adoration of the Kings.* 1481. Wood, 96 × 97 in. Florence, Uffizi.
Commissioned as an altar-piece for the monastery of San Donato a Scopeto outside Florence, and 'conceived in a mood of allegory and romance' (Kenneth Clark), Leonardo finished the underpainting only and never delivered the picture.

14–17. *The Virgin of the Rocks.* About 1483. Wood, transferred to canvas, $77\frac{1}{2}$ × 47 in. Paris, Louvre.
Centre panel of an altar-piece commissioned by the Confraternity of the Immaculate Conception in Milan shortly after Leonardo's arrival. Opinions are divided whether this was the picture in London or the later version of the same composition (Plates 23–6).

18. *Portrait of a Musician.* About 1485 (?). Wood, 17 × $12\frac{1}{4}$ in. Milan, Ambrosiana Gallery.
The lower part of the picture has remained unfinished. The hand and the sheet of music with the fragmentary inscription CANT . . . ANG . . . were revealed when the picture was cleaned in 1905. – Leonardo himself is described by contemporaries as an exquisite musician.

19. *Portrait of a Woman,* known as *La belle Ferronnière.* 1486–8. Wood, $24\frac{3}{8}$ × $17\frac{1}{4}$ in. Paris, Louvre.
Leonardo's authorship of this painting has been doubted by some scholars.

20–2. *The Last Supper.* 1495–7. Wall-painting, c. 15 × 28 ft. Milan, Santa Maria delle Grazie.
'Amen, I say to you that one of you is about to betray me.' In choosing to depict the Apostles' reactions to these words of Christ, Leonardo created a dramatic and for his time revolutionary composition, which achieved immediate fame and which has continued to evoke universal admiration as one of the great masterpieces of Italian Renaissance art. Several of Leonardo's sketches for the composition and for individual heads (see Plates 40, 41) have been preserved. The three lunettes at the top depict the coats-of-arms of the Houses of Sforza and Este flanked by ornamental fruit and leaves.
Unfortunately Leonardo painted in oils on plaster – with the lamentable results that are summed up so eloquently by Pater (p. 10 above). The most recent restoration of the painting took place in 1955.

23–6. *The Virgin of the Rocks.* Begun about 1495, completed about 1506. Wood, $74\frac{5}{8}$ × $47\frac{1}{4}$ in. London, National Gallery.
Parts of the picture have remained unfinished. It differs from the earlier version of the composition (Plates 14–17), e.g. in the plants, the background, the posture and draperies of the angel, the Christ Child's head, the haloes; and

the infant St. John now has a cross.

27. *Portrait of Mona Lisa.* About 1505(?). Wood, $30\frac{1}{4}$ × $20\frac{7}{8}$ in. Paris, Louvre.
Lisa Gherardini, born in 1479, was married to Francesco del Giocondo. – Pater devotes some of his most eloquent words to this famous portrait (p. 11).

28. *Virgin and Child with St. Anne and the infant St. John the Baptist.* Cartoon, black chalk, heightened with white, on paper attached to canvas, $55\frac{3}{4}$ × 41 in. London, National Gallery.
St. Anne points to the Saviour's divine origin, while He blesses the Baptist. – Some scholars date the cartoon from about 1495, others from 1505–6 or 1508–10. It was in the possession of the Royal Academy of Arts from the eighteenth century until 1962, when it was bought for the nation with the help of a public subscription.

29–30. *Virgin and Child with St. Anne and the Lamb.* 1510–12. Wood, 67 × $50\frac{3}{4}$ in. Paris, Louvre.
Leonardo is known to have worked on three versions of this subject. One of them is lost, the other two are represented by Plates 28 and 29. The lost cartoon is described in a letter of 1501 as having depicted 'the infant Christ about one year old, freeing himself from his mother's arms and seizing a lamb and apparently about to embrace it. The mother . . . is catching the Child to draw it away from the lamb, that sacrificial animal which signifies the Passion.' This motif recurs in the present picture. The fantastic rock formations are found in several of Leonardo's works.

31. *St. John the Baptist.* About 1509. Wood, $27\frac{1}{8}$ × $22\frac{3}{8}$ in. Paris, Louvre.
With the same gesture as St. Anne in Plate 28 he points to the source of Salvation.

32. *Self-Portrait of Leonardo.* About 1512. Red chalk, $13\frac{3}{8}$ × $8\frac{3}{8}$ in. Turin, Royal Library.

33. *Virgin and Child with a Cat.* 1478–81. Pen over black chalk, $11\frac{1}{8}$ × $7\frac{7}{8}$ in. London, British Museum.
Leonardo made several studies of this subject. See also Plate 45.

34. *Study of a Woman's Hands.* 1478–80. Silverpoint, heightened with white, on pink prepared paper, $8\frac{1}{2}$ × $5\frac{7}{8}$ in. Windsor Castle, Royal Library.
This may have been a study for the lower part (now missing) of the portrait of Ginevra de' Benci (Plate 8).

35. *Profile of a Warrior in Armour.* About 1480. Silverpoint on cream prepared paper, $11\frac{1}{4}$ × $8\frac{1}{4}$ in. London, British Museum.
'A feat of virtuosity that Leonardo never surpassed' (Kenneth Clark).

36. *Violets and other Flowers.* About 1483. Pen over metalpoint, $7\frac{1}{4}$ × 8 in. Venice, Academy.
Throughout his life Leonardo made careful drawings of plants and trees, and he depicted many flowers and shrubs in his paintings. See

L. Goldscheider, *Leonardo da Vinci, Landscapes and Plants*, London, 1952.

37. *The Proportions of the Human Figure.* 1485–90. Pen, 13½ × 9⅝ in. Venice, Academy.
The drawing illustrates the scheme of human proportions given by the Roman writer Vitruvius. The text, in Leonardo's habitual mirror-writing, translates a relevant passage from Vitruvius.

38. *Studies for an Equestrian Monument to Francesco Sforza.* 1490–1. Silverpoint on blue prepared paper, 8⅜ × 6¼ in. Windsor Castle, Royal Library.
Shortly before he moved to Milan, Leonardo wrote to Ludovico Sforza offering his services as a specialist in artillery and military engineering, and he also offered to make 'a bronze horse' to the immortal glory of the Duke's father. During the next twelve years he made numerous drawings for this monument, and in 1493 he exhibited a colossal clay model, which has not survived and which was never cast in bronze. In 1499 Duke Ludovico was driven out by a French army, and Leonardo also left Milan.

39. *Five Grotesque Heads.* About 1494. Pen on white paper, 10¼ × 8⅛ in. Windsor Castle, Royal Library.
A psychologist once suggested that the crowned head in the centre is a personification of megalomania; the profile head of a woman with protruding lower lip is a typical example of *dementia paralytica;* the woman's head on the left suggests mental imbecility; the head with open mouth, raving lunacy; and the full-face head top right, obstinacy.

40. *Head of Judas.* About 1495–7. Red chalk on red paper, 7 × 5⅞ in. Windsor Castle, Royal Library.
Vasari has an anecdote that Leonardo, while working on the *Last Supper* in the Dominican monastery in Milan, revenged himself on the importunate Prior by portraying him as the embodiment of treachery and cruelty (the fourth head from the left in Plate 20). In the drawing the head is still beardless and not expressive of evil.

41. *Head of St. James the Greater.* About 1495–7. Red chalk on white paper, 9⅞ × 6¾ in. Windsor Castle, Royal Library.
Another study for the *Last Supper* (Plate 20), where St. James, the fifth Apostle from the right, is bearded and looks rather older. The pen sketch below is connected with plans for the fortification of the Sforza Castle in Milan.

42. *Heads of Two Men.* About 1503–4. Black and red chalk, 7½ × 7⅞ in. Budapest, Museum of Fine Arts.

A study for the *Battle of Anghiari* cartoon (see notes 2 and 29).

43. *Studies for an Equestrian Monument to Marshal Trivulzio.* 1508–11. Pen and bistre on greyish paper, 11 × 7⅞ in. Windsor Castle, Royal Library.
This monument was planned in honour of Giacomo Trivulzio, a Milanese soldier who had entered the service of Louis XII of France and commanded the French troops against Ludovico Sforza ten years earlier. It was to show Trivulzio on horseback, holding his baton, standing on an elaborate base containing his sarcophagus. Leonardo made several sketches for the monument before the plan was abandoned.

44. *Studies of a Woman's Head with Braided Hair.* 1509–10. Pen over black chalk, on white paper, 7⅞ × 6⅜ in. Windsor Castle, Royal Library.
Leonardo's painting of Leda and the Swan, with the four infants (Castor and Pollux, Helen and Clytaemnestra) emerging from two eggs, has been lost, but we have several copies from other hands. These studies for the head of Leda are remarkable for the elaborate coiffures with interlaced patterns which Leonardo used also in quite different contexts.

45. *Sketches of Cats.* 1513–14. Pen with touches of wash, over black chalk, on white paper, 10⅝ × 8¼ in. Windsor Castle, Royal Library.
Kenneth Clark has pointed out that this sheet was probably part of a projected treatise on the movements of animals.

46. *An Allegory.* About 1513. Red chalk on brownish-grey paper 6⅝ × 11 in. Windsor Castle, Royal Library.
Several political and other interpretations have been suggested, but the true significance of the allegory has yet to be established.

47. *A Deluge.* About 1515. Black chalk and ink, 6¾ × 8 in. Windsor Castle, Royal Library.
This is one of the famous series of ten 'Deluge' drawings, in which the artist tried to give form to what the scientist had learnt in his theoretical studies.

48. *Rider in Masquerade Costume.* About 1515. Pen over black chalk, on brownish paper, 9½ × 6 in. Windsor Castle, Royal Library.

The drawings in the Royal Library (Plates 34, 38–41, 43–48) are reproduced by gracious permission of Her Majesty The Queen.

Sources of colour reproductions: Scala, Florence, Plates 9, 11–13, 19, 31, 32; Ronald Sheridan, London, Plates 23, 25, 26; Photothèque, Paris, Plate 27; National Gallery, London, Plates 24, 28; Alte Pinakothek, Munich, Plate 7; and Phaidon Press archives.

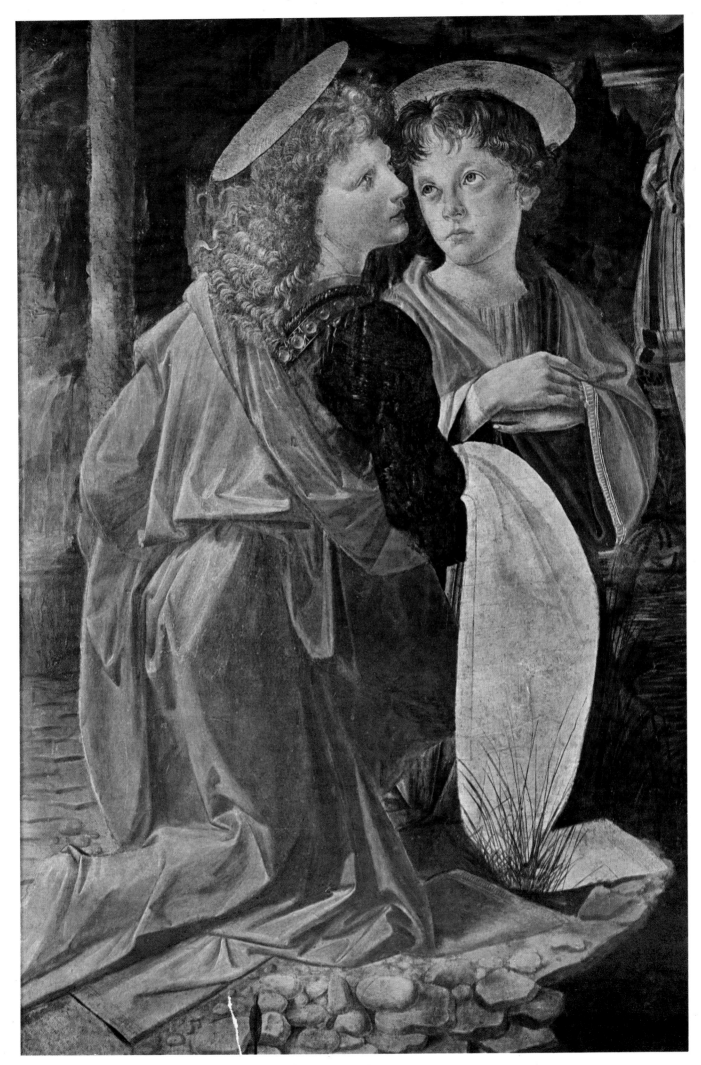

1. *TWO ANGELS*. Detail from Verrocchio's *Baptism of Christ*. About 1472. The angel on the left was painted

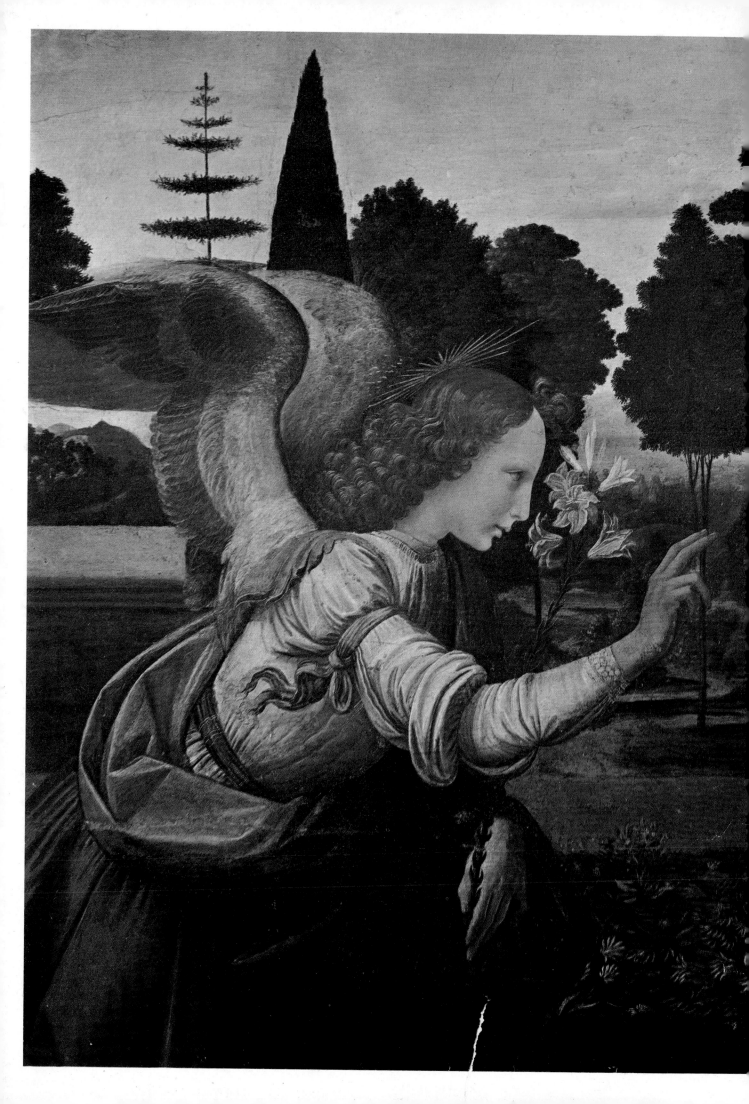

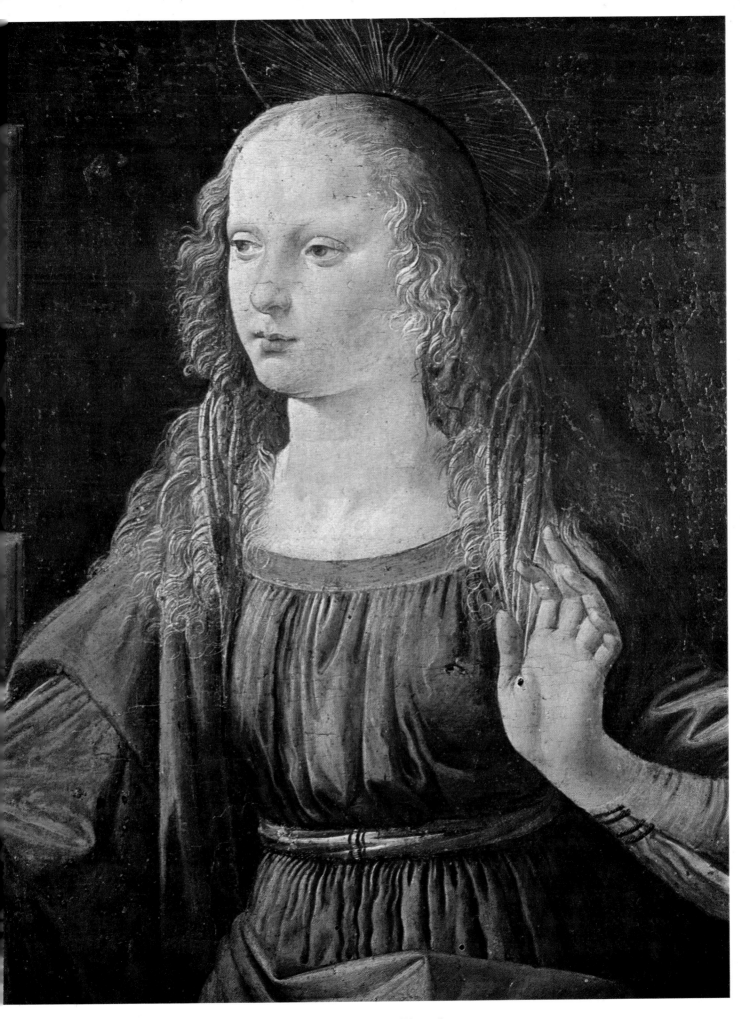

3. *THE VIRGIN OF THE ANNUNCIATION.* Detail from Plate 4b

2. *THE ANGEL OF THE ANNUNCIATION.* Detail from Plate 4b

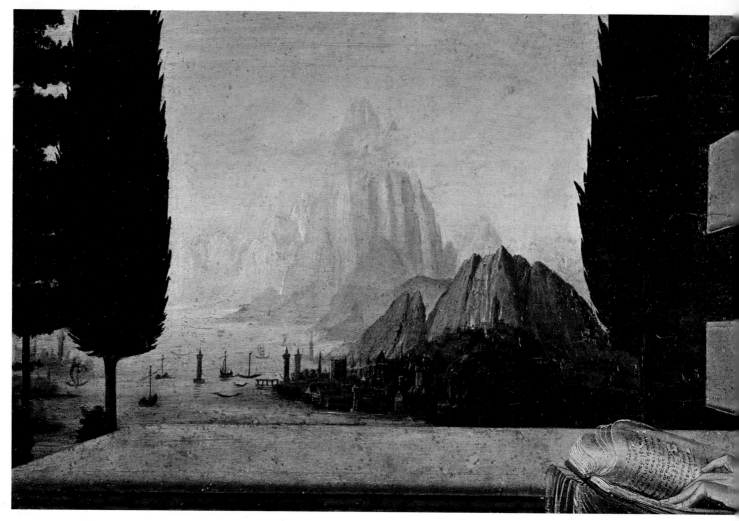

4a. *DISTANT LANDSCAPE.* Detail from Plate 4b

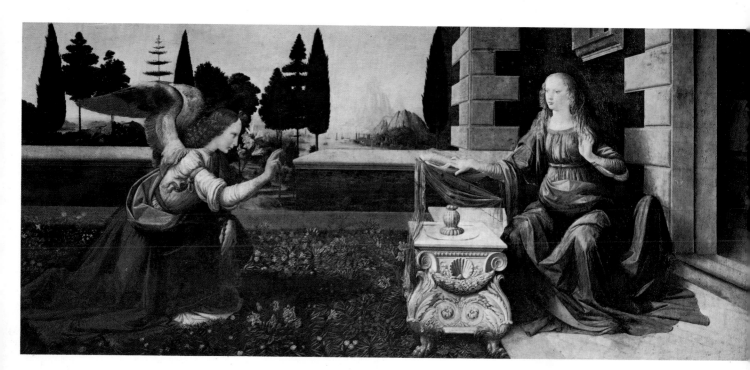

4b. *THE ANNUNCIATION.* 1476–8. Florence, Uffizi

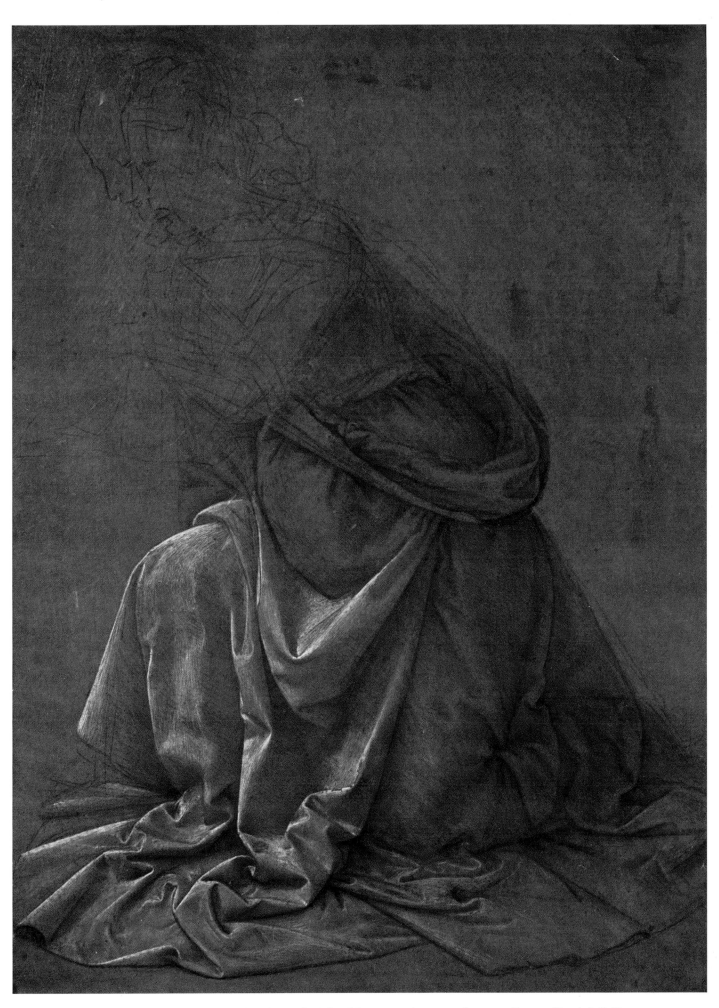

5. *DRAPERY STUDY*. Silverpoint, heightened with white, on red prepared paper. Rome, Corsini Gallery

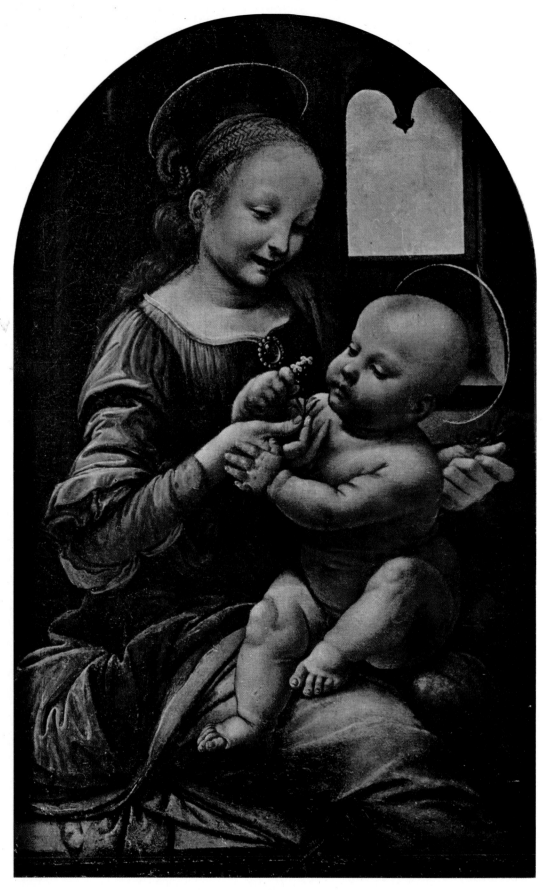

6. *VIRGIN AND CHILD*, known as *MADONNA BENOIS*. 1478–80.
Leningrad, Hermitage

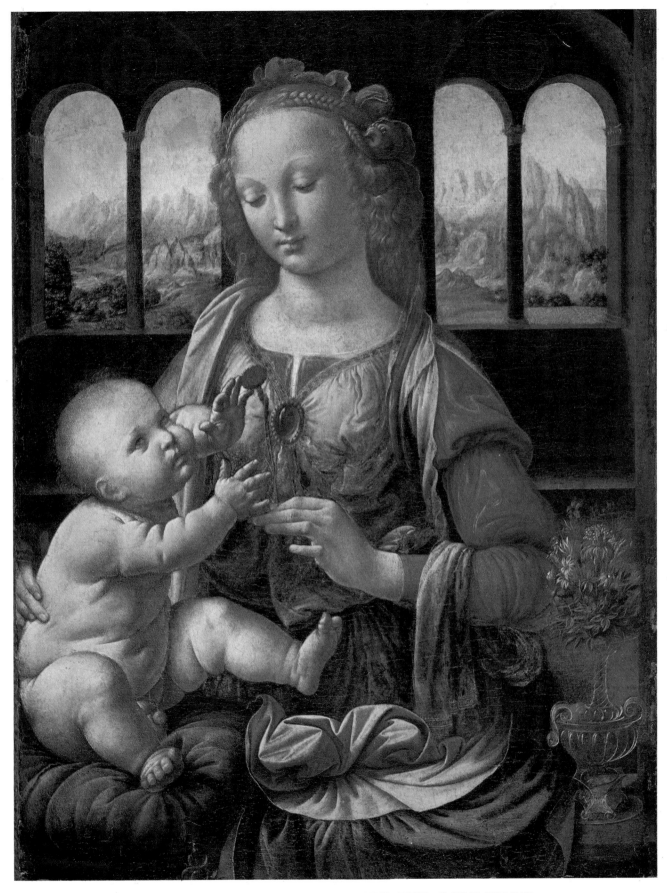

7. *VIRGIN AND CHILD*, known as *MADONNA WITH THE CARNATION*.
Munich, Alte Pinakothek

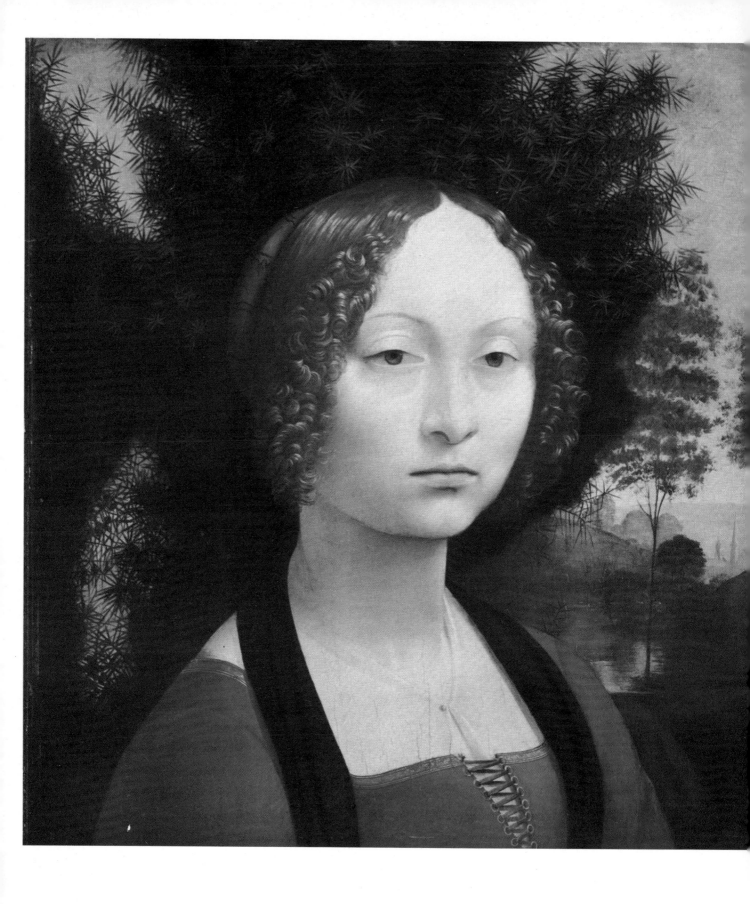

8. *PORTRAIT OF GINEVRA DE' BENCI*. 1478–80. Washington, D.C., National Gallery of Art

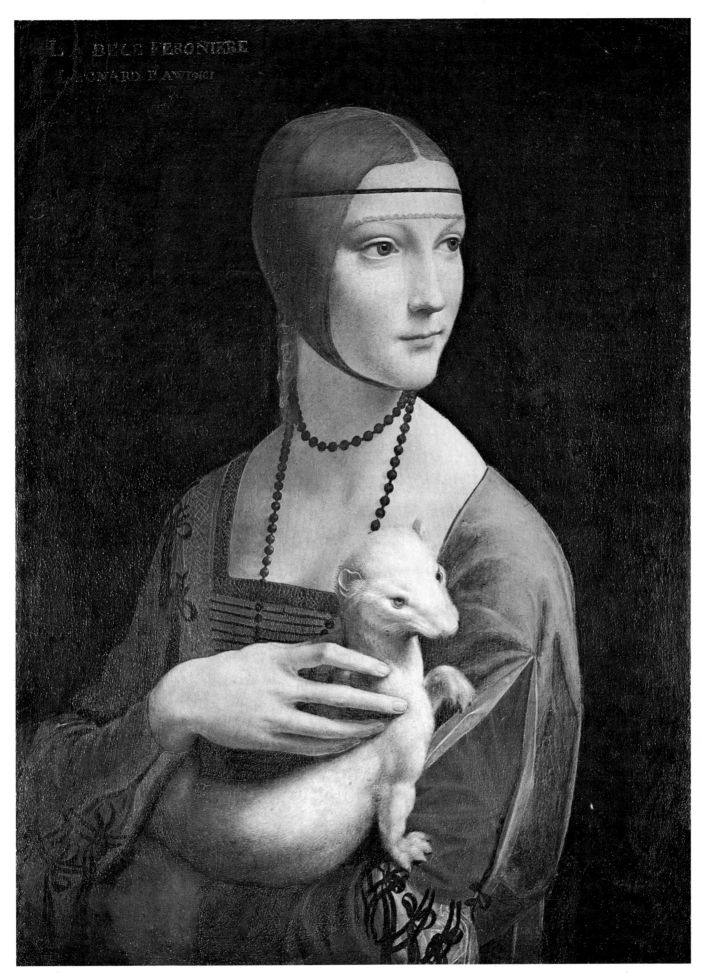

9. *PORTRAIT OF A LADY WITH AN ERMINE* (Cecilia Gallerani?). 1483–4. Cracow, National Museum

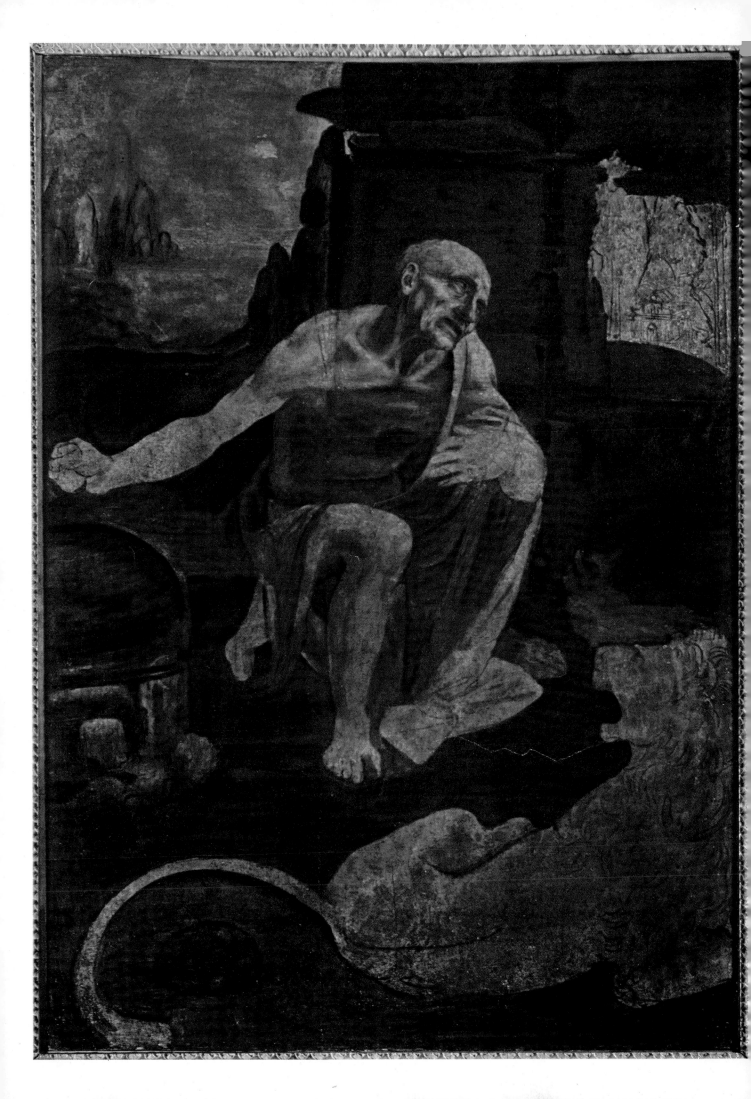

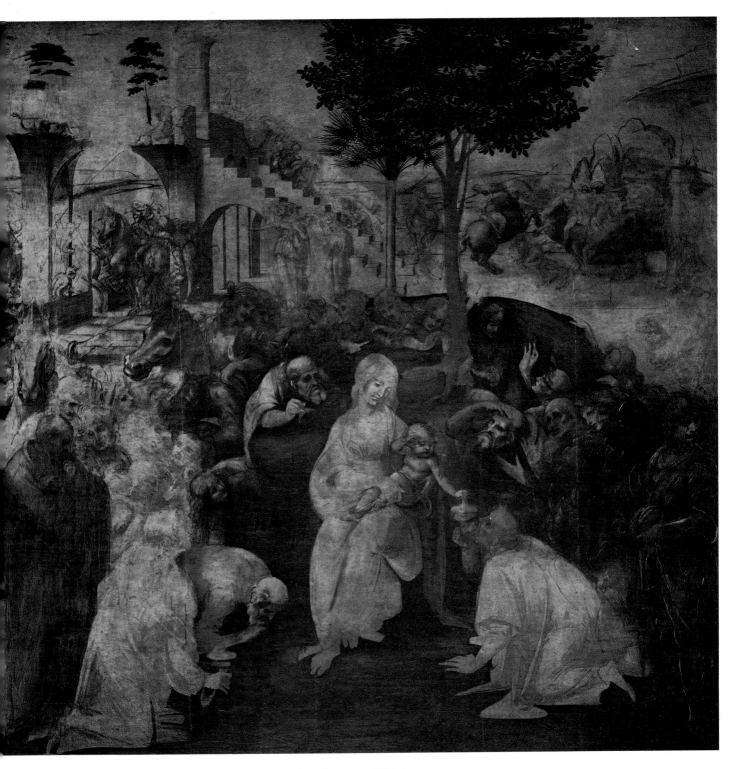

. THE ADORATION OF THE KINGS. 1481. Florence, Uffizi

b. ST. JEROME IN PENITENCE. Unfinished. Rome, Vatican Gallery

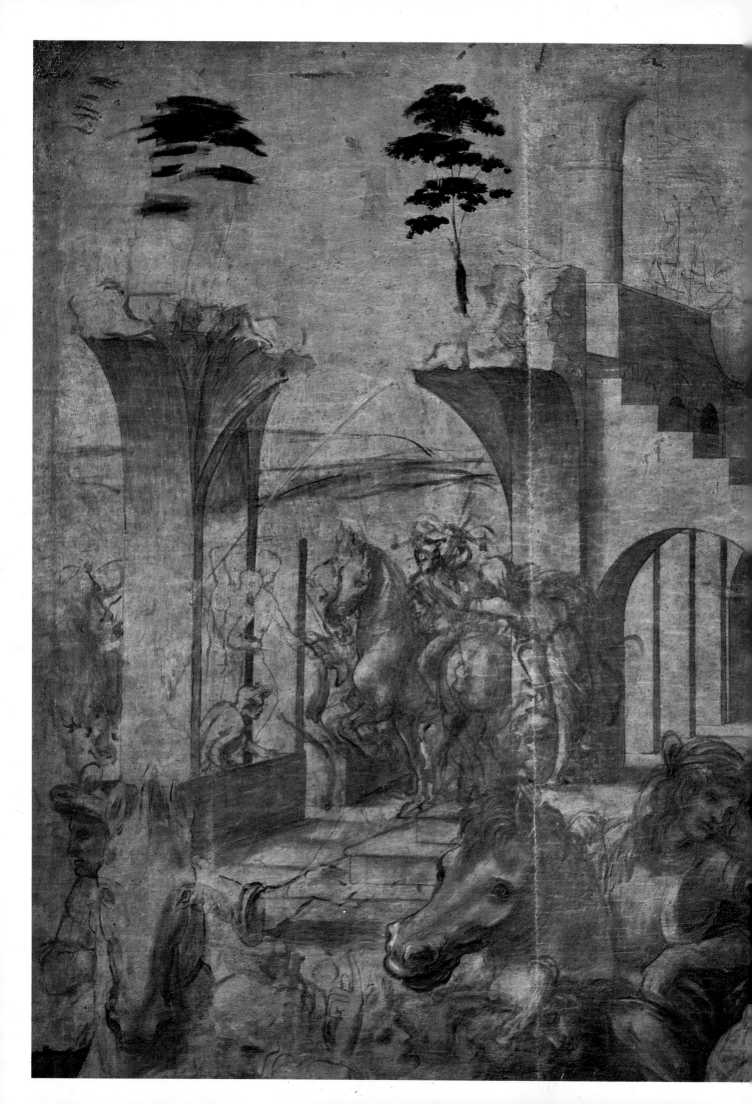

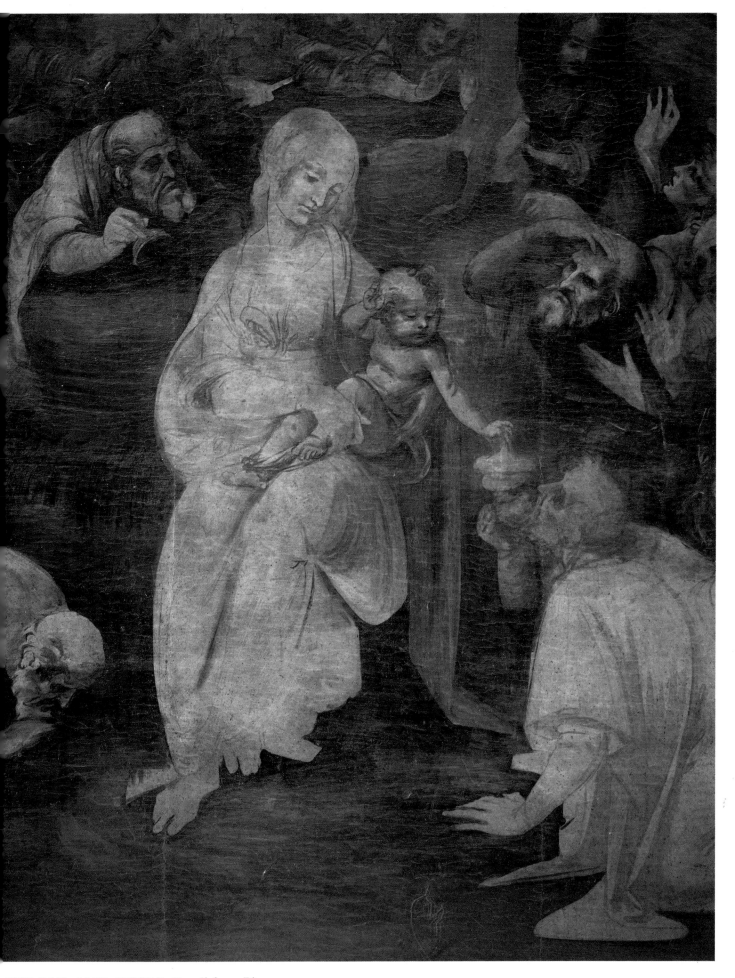

VIRGIN AND CHILD. Detail from Plate 11

HORSEMEN AND FANTASTIC ARCHITECTURE. Detail from Plate 11

14. *IRISES AND WOOD ANEMONES.* Detail from Plate 15

15. *THE VIRGIN OF THE ROCKS.* About 1483. (Earlier version; cf. Plate 24.) Paris, Lou

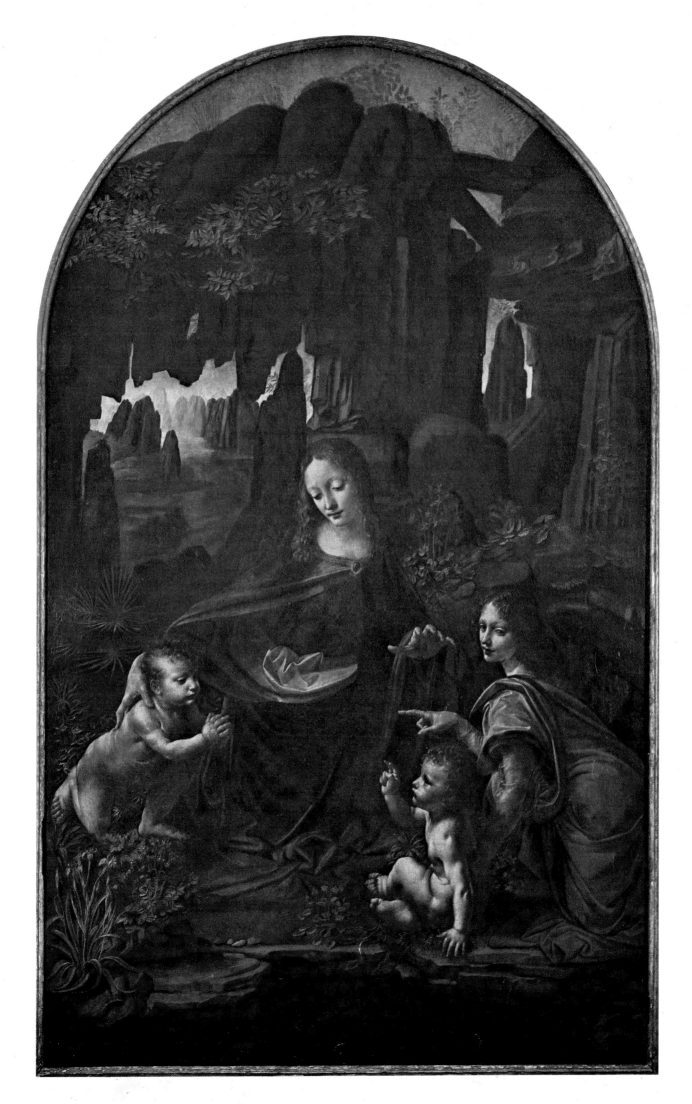

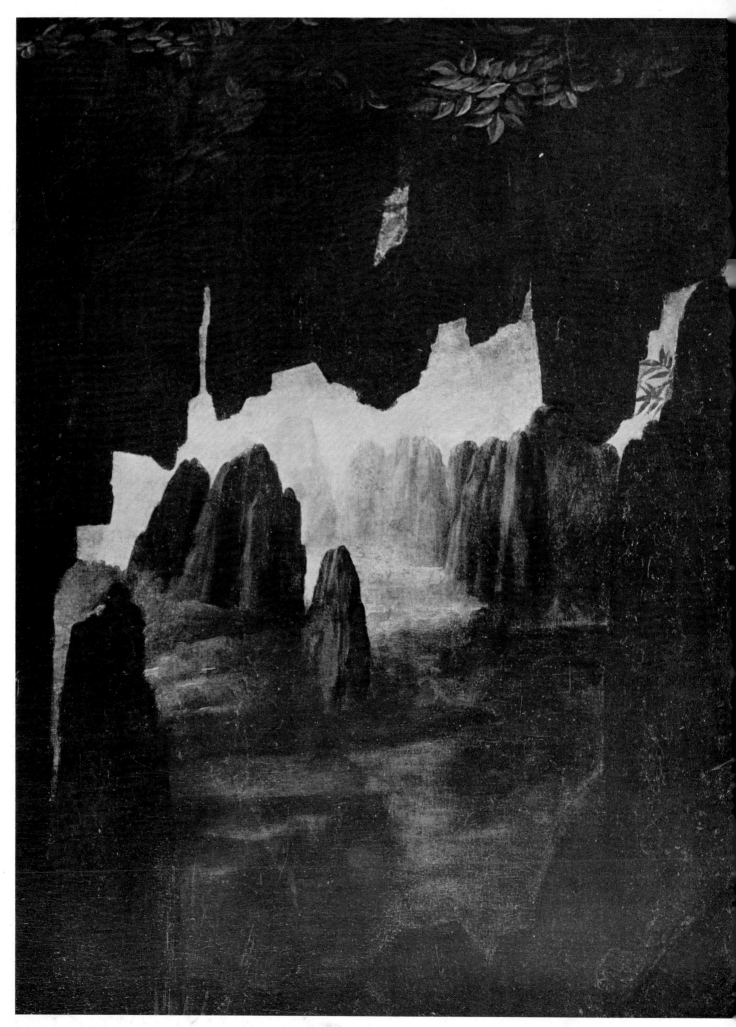

16. *ROCKS AND DISTANT LANDSCAPE.* Detail from Plate 15

17. *ANGEL.* Detail from Plate 1

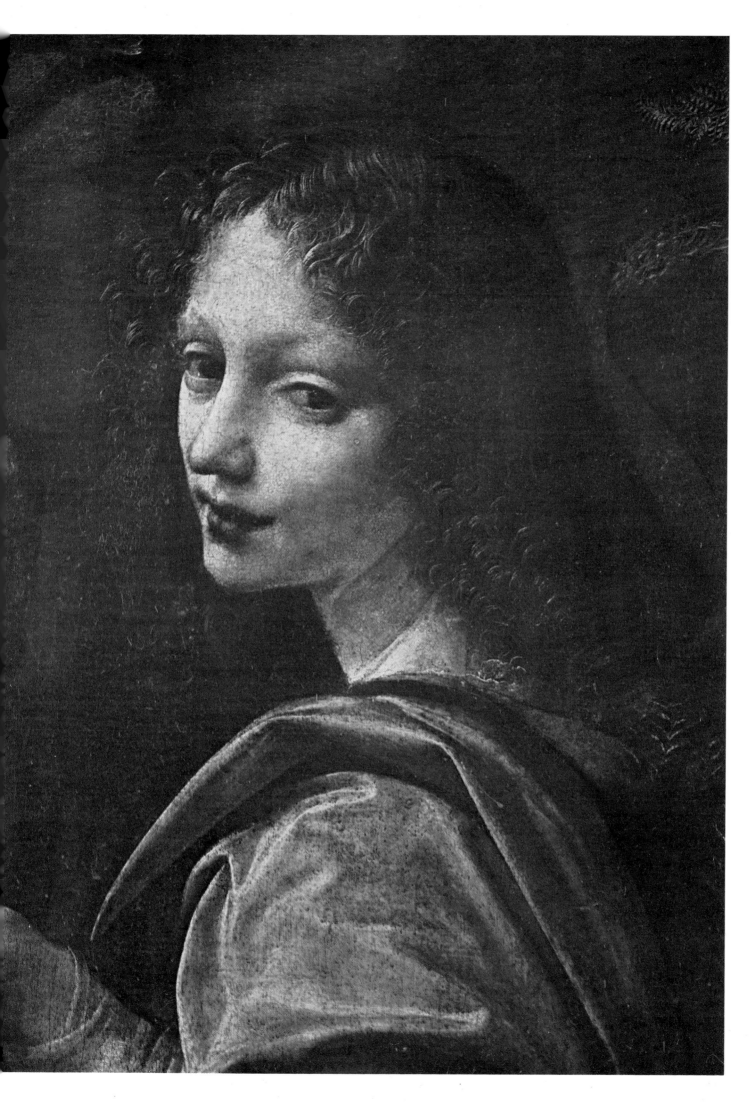

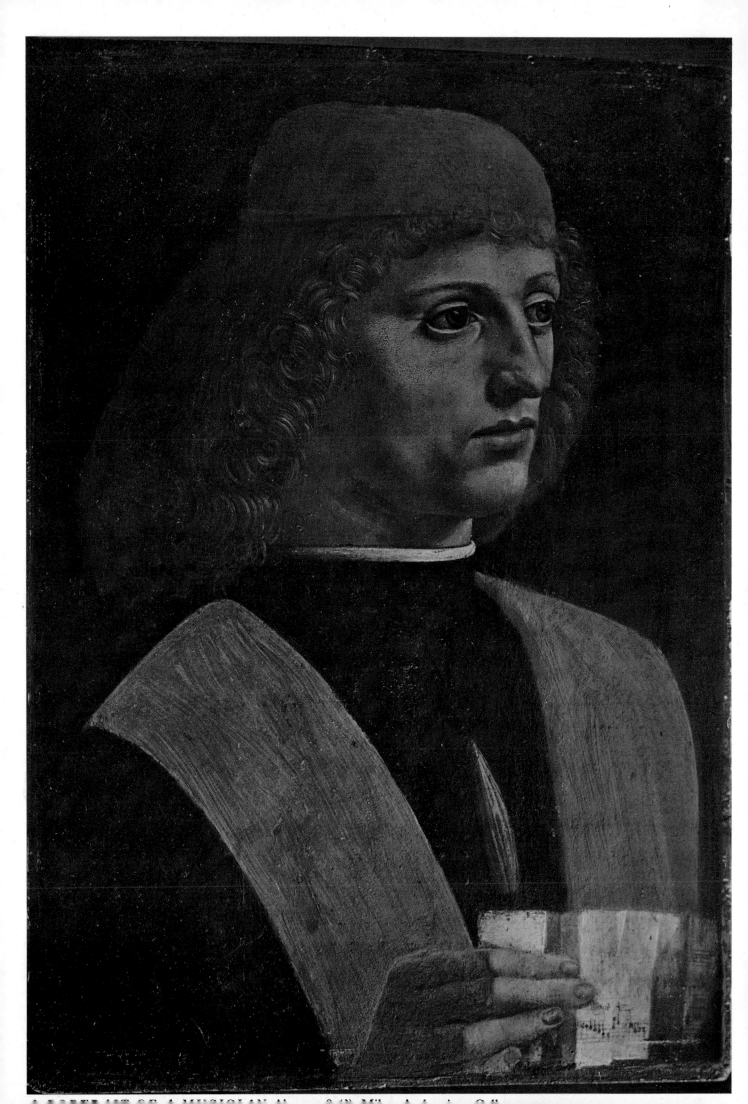

A PORTRAIT OF A MUSICIAN. No. 98 (?) Milan, Ambrosian Gallery

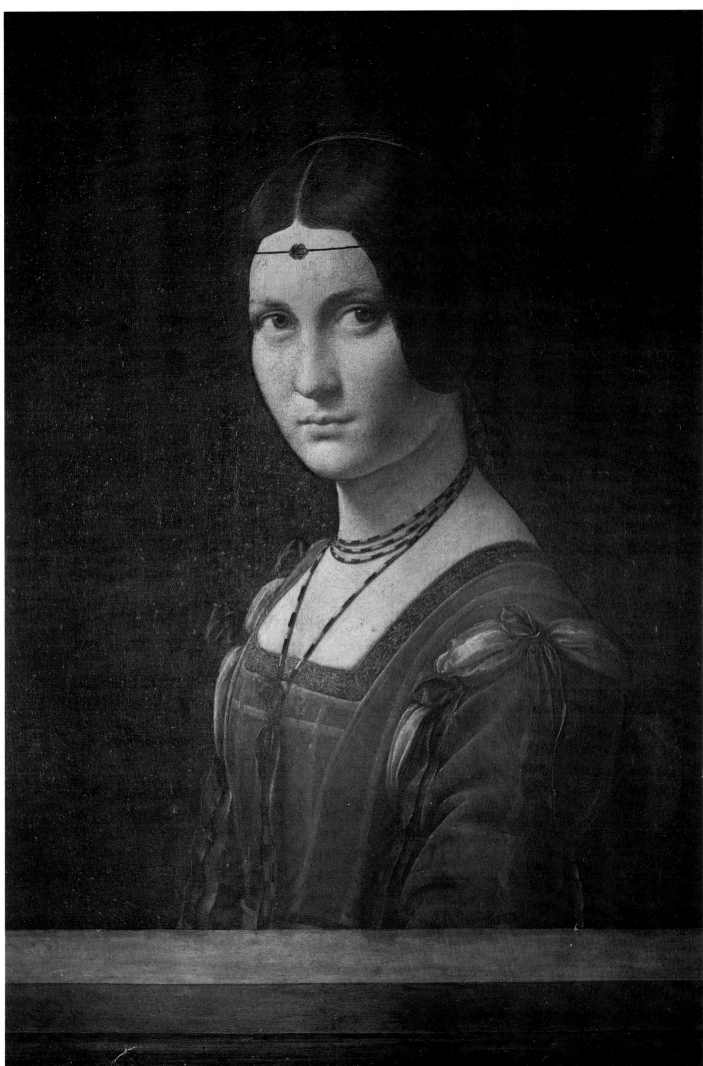

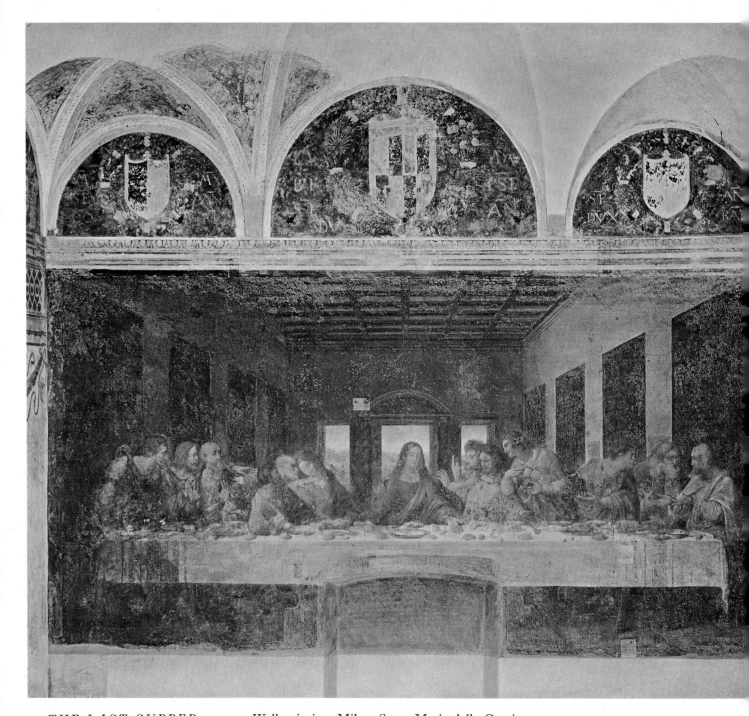

20. *THE LAST SUPPER*. 1495–7. Wall-painting. Milan, Santa Maria delle Grazie

21. *CHRIST*. Detail from ▮

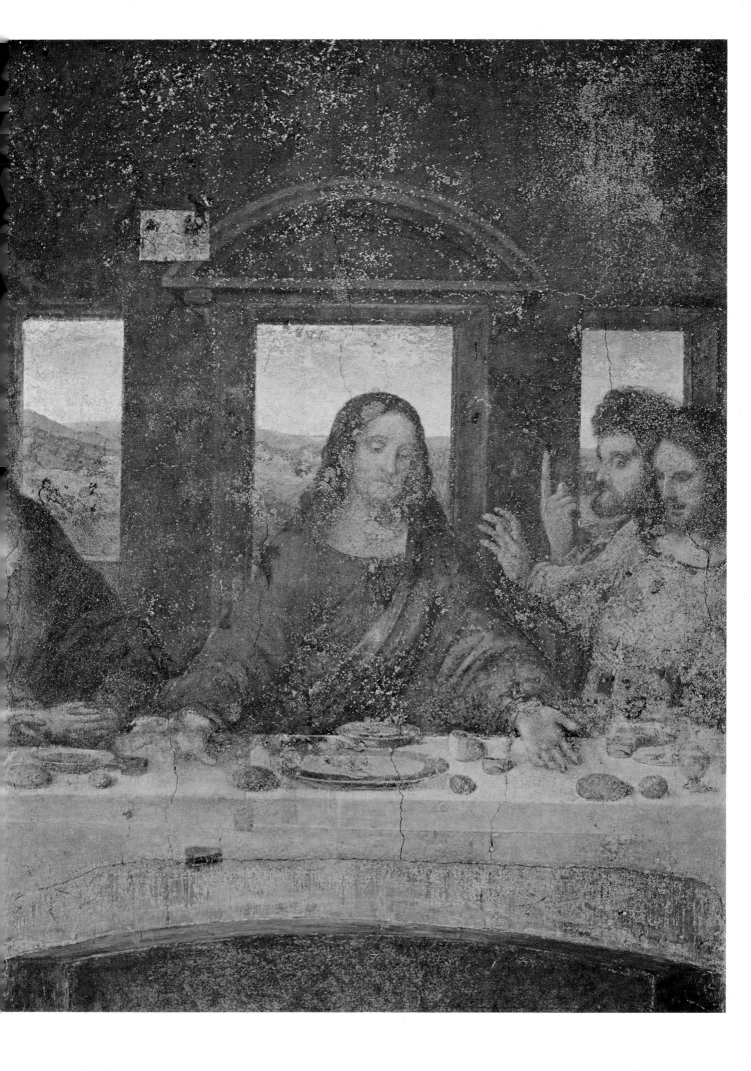

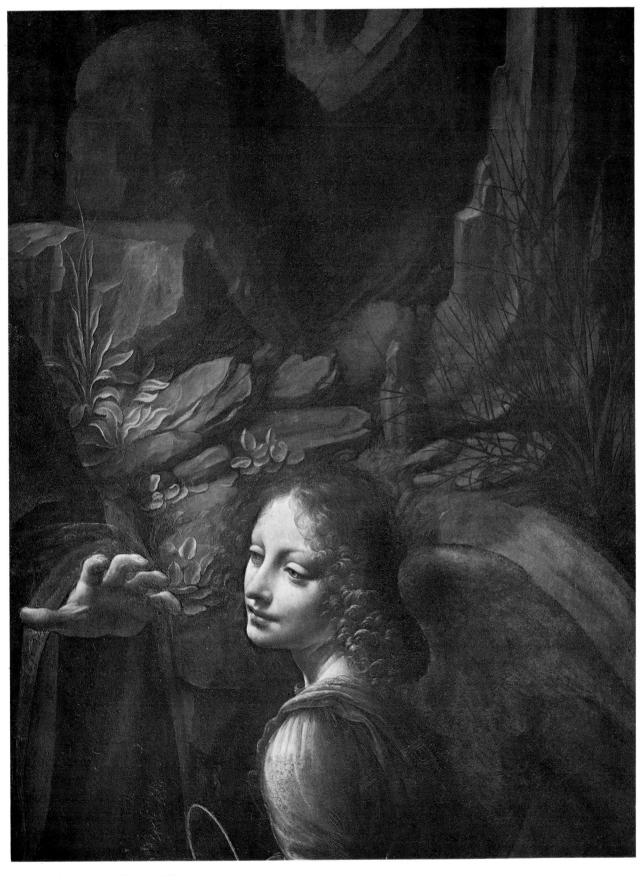

23. *ANGEL*. Detail from Plate 24

22. *FRUIT AND LEAVES*. Detail from Plate 20

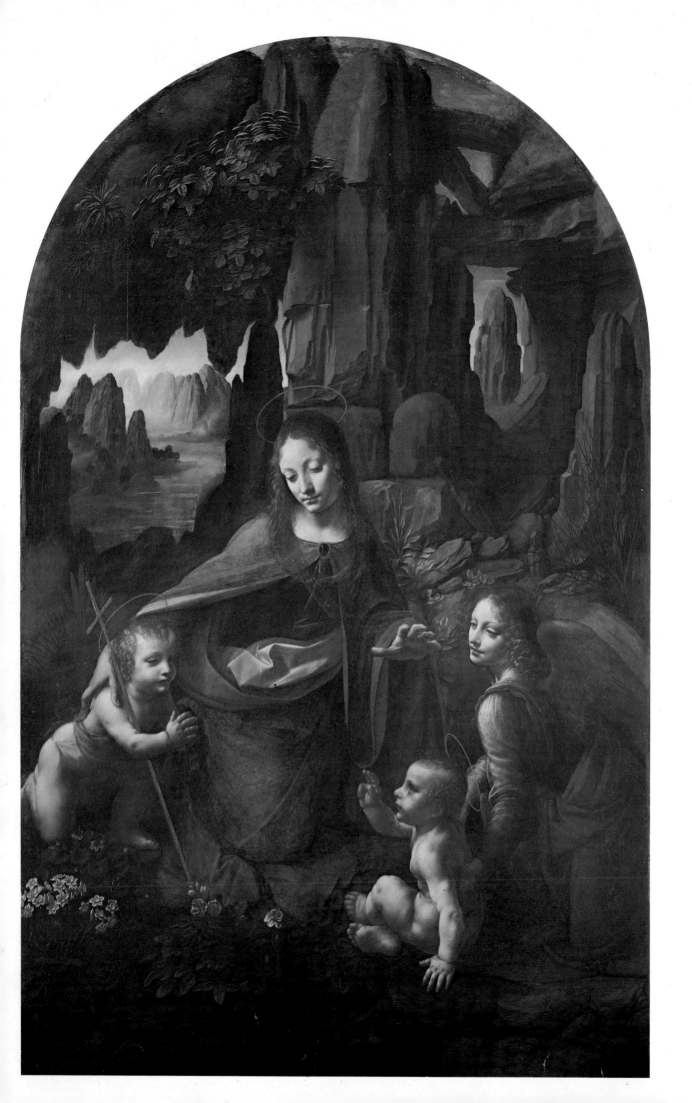

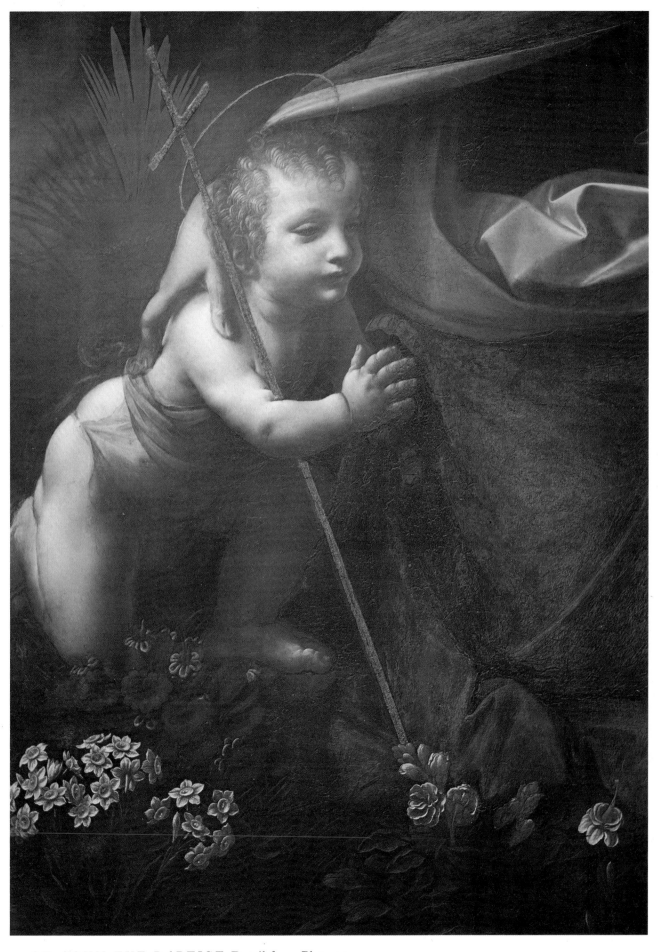

25. *ST. JOHN THE BAPTIST*. Detail from Plate 24

24. *THE VIRGIN OF THE ROCKS*. Begun about 1495, completed about 1506. (Later version; cf. Plate 15.) London, National Gallery

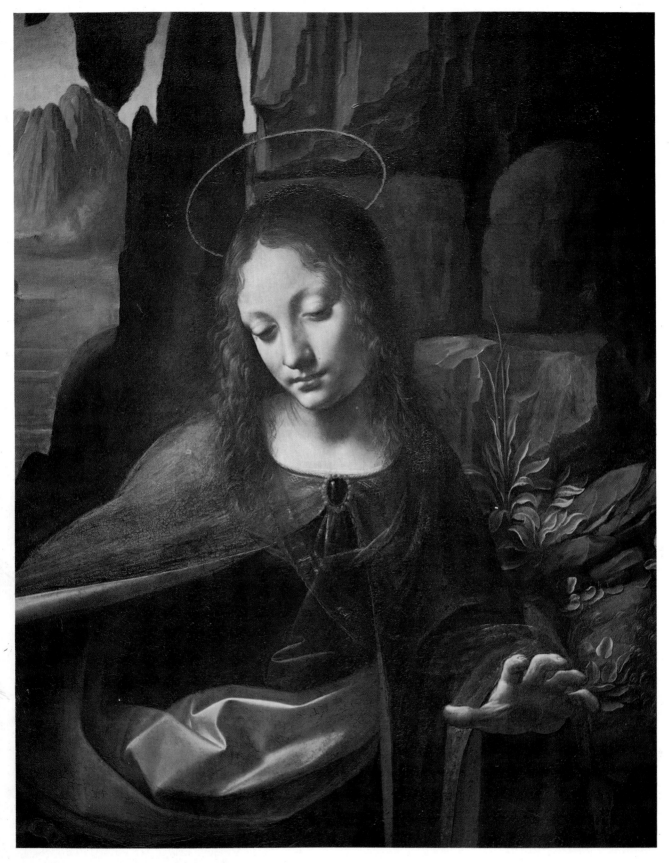

26. *THE VIRGIN*. Detail from Plate 24

27. *PORTRAIT OF MONA LISA*. About 1505(?). Paris, Louvre

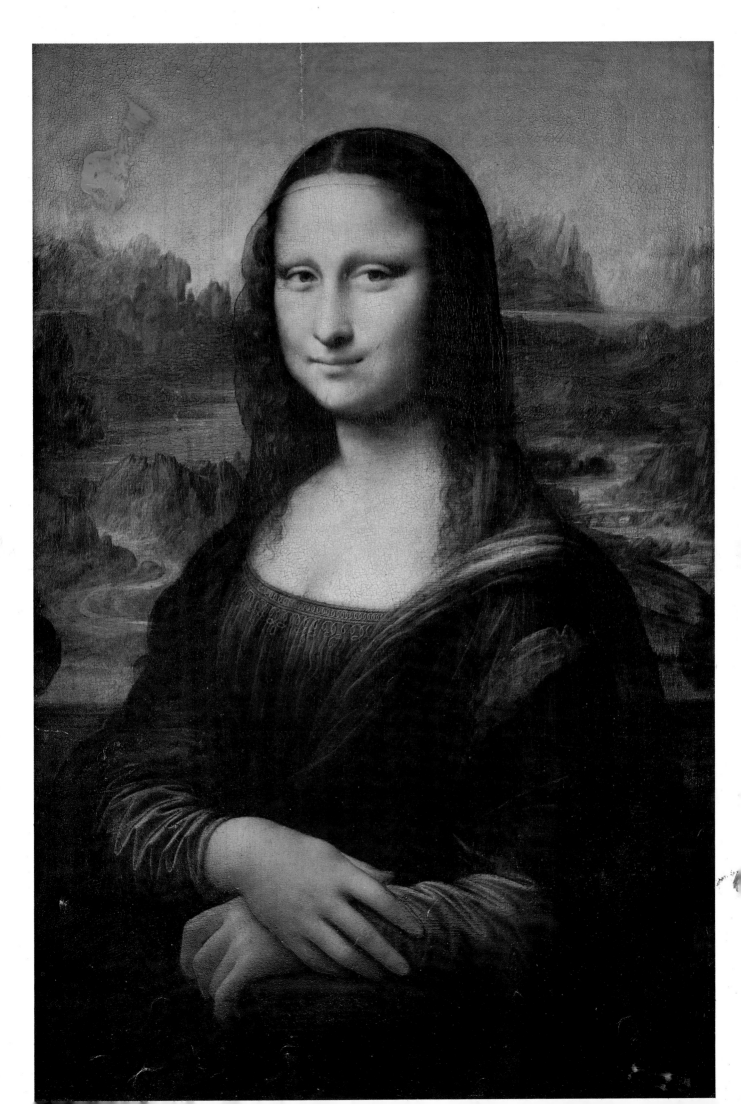

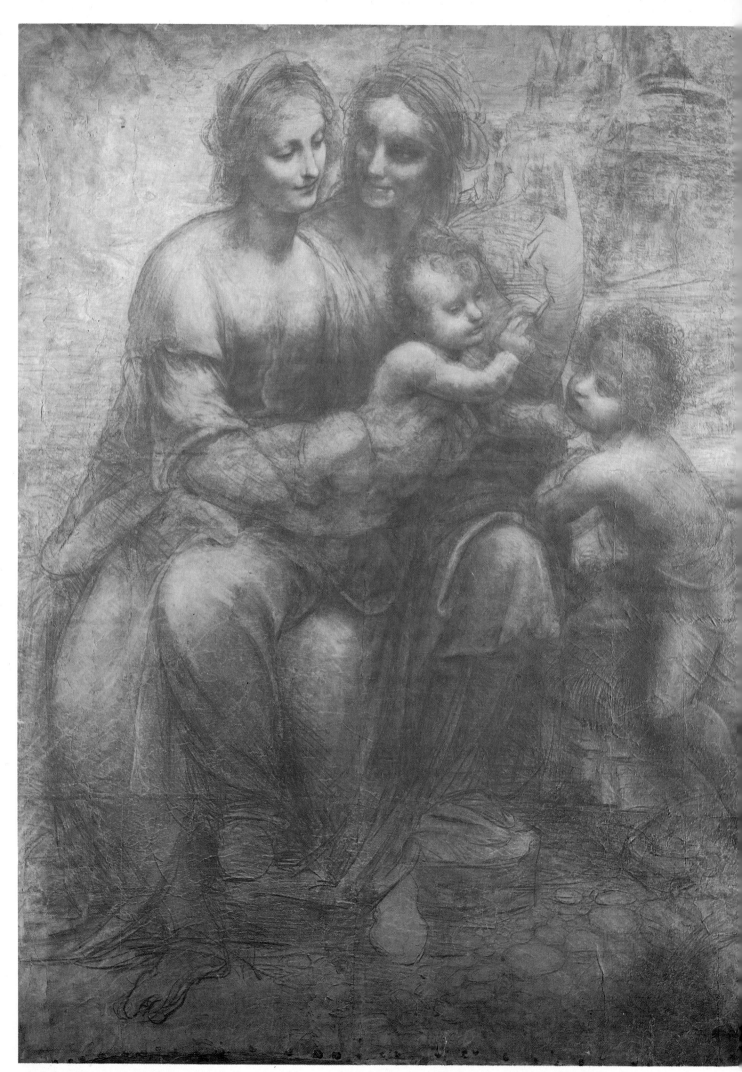

28 VIRGIN AND CHILD WITH ST. ANNE AND THE INFANT ST. JOHN THE BAPTIST Cartoon

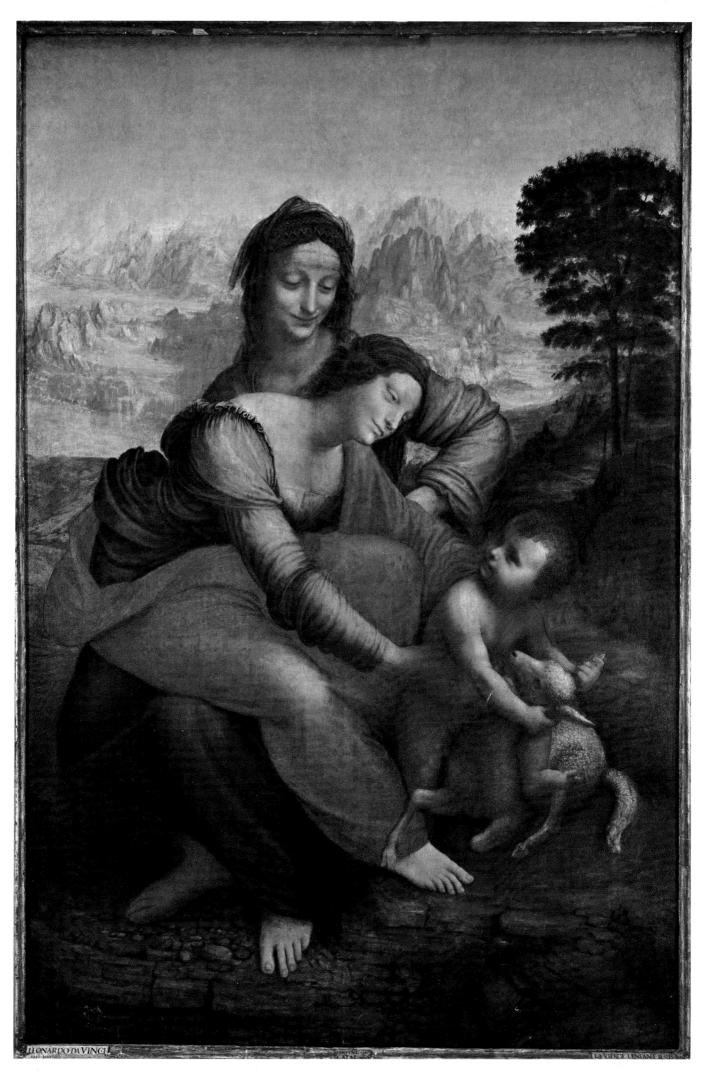

29. *VIRGIN AND CHILD WITH ST. ANNE AND THE LAMB.* 1510–12. Paris, Louvre

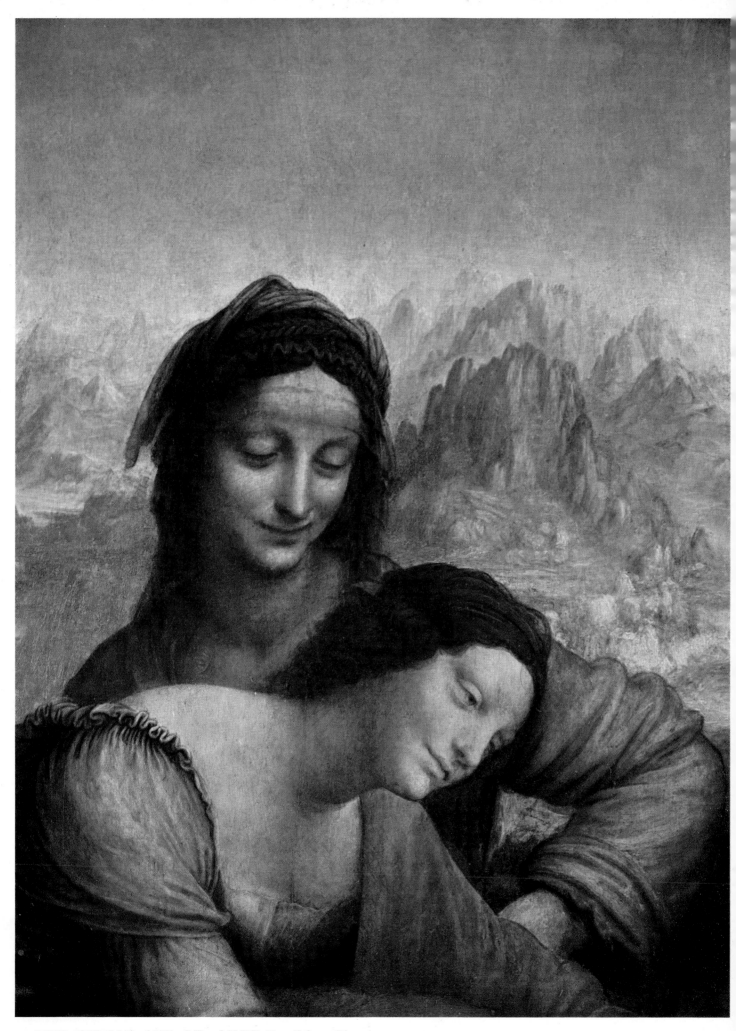

30. *THE VIRGIN AND ST. ANNE.* Detail from Plate 29

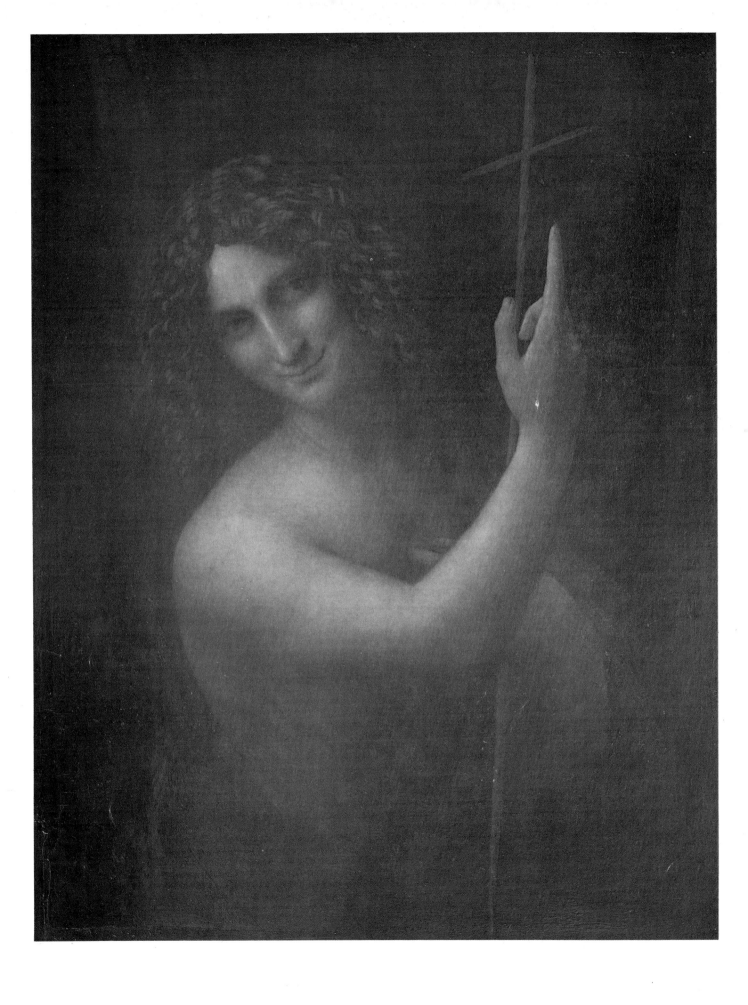

31. *ST. JOHN THE BAPTIST.* About 1509. Paris, Louvre

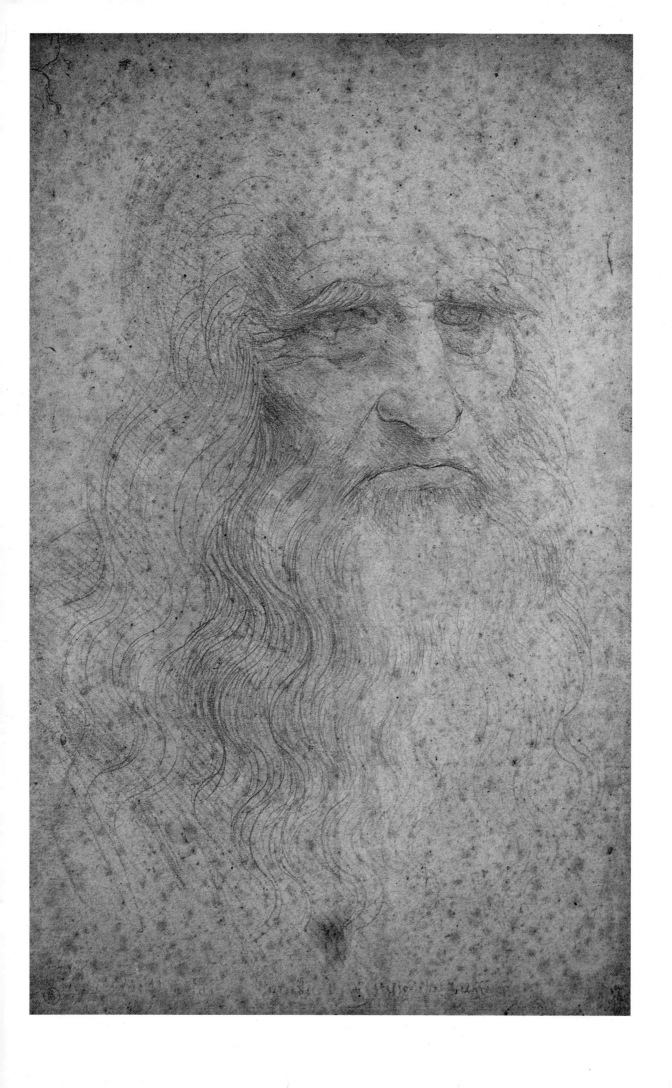

22 *SELF-PORTRAIT OF LEONARDO* About 1512 Red chalk Turin Royal Library

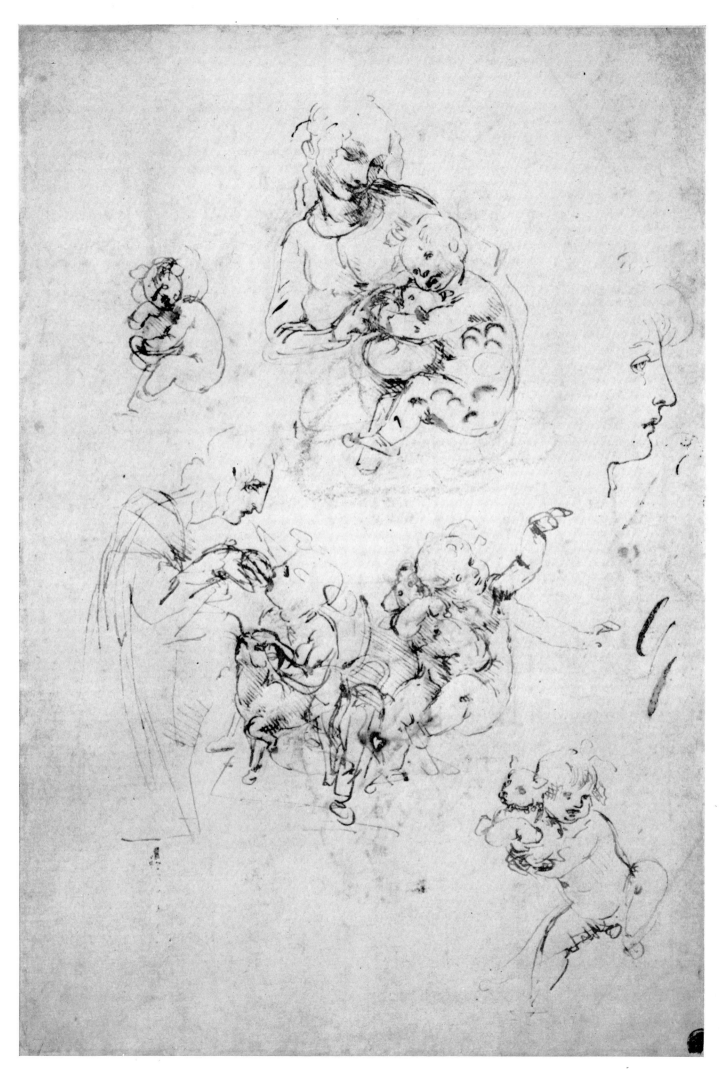

33. *STUDIES OF THE VIRGIN AND CHILD WITH A CAT.* 1478–81. Pen over black chalk.

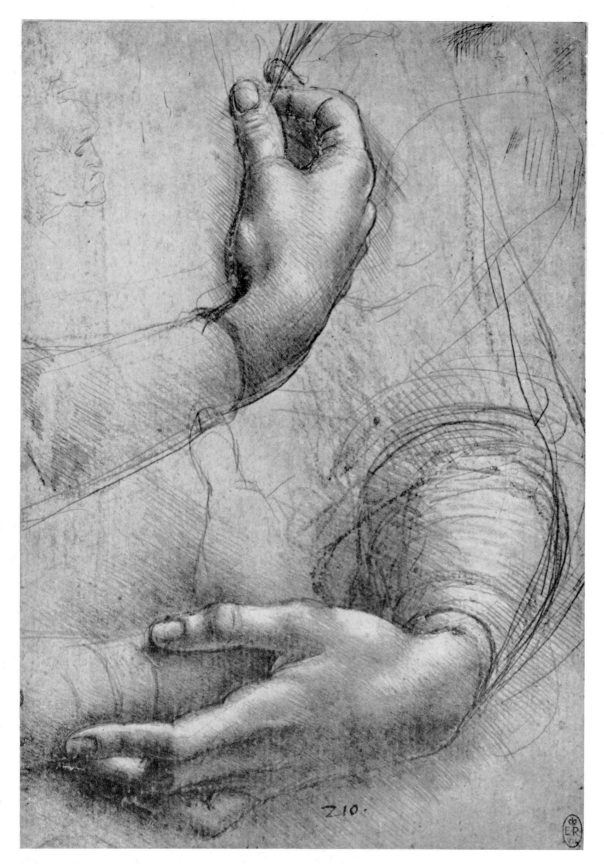

34. *STUDY OF A WOMAN'S HANDS*. 1478–80. Silverpoint, heightened with white,
on pink prepared paper. Windsor Castle, Royal Library

35. *PROFILE OF A WARRIOR IN ARMOUR*. About 1480.
Silverpoint on cream prepared paper. London, British Museum

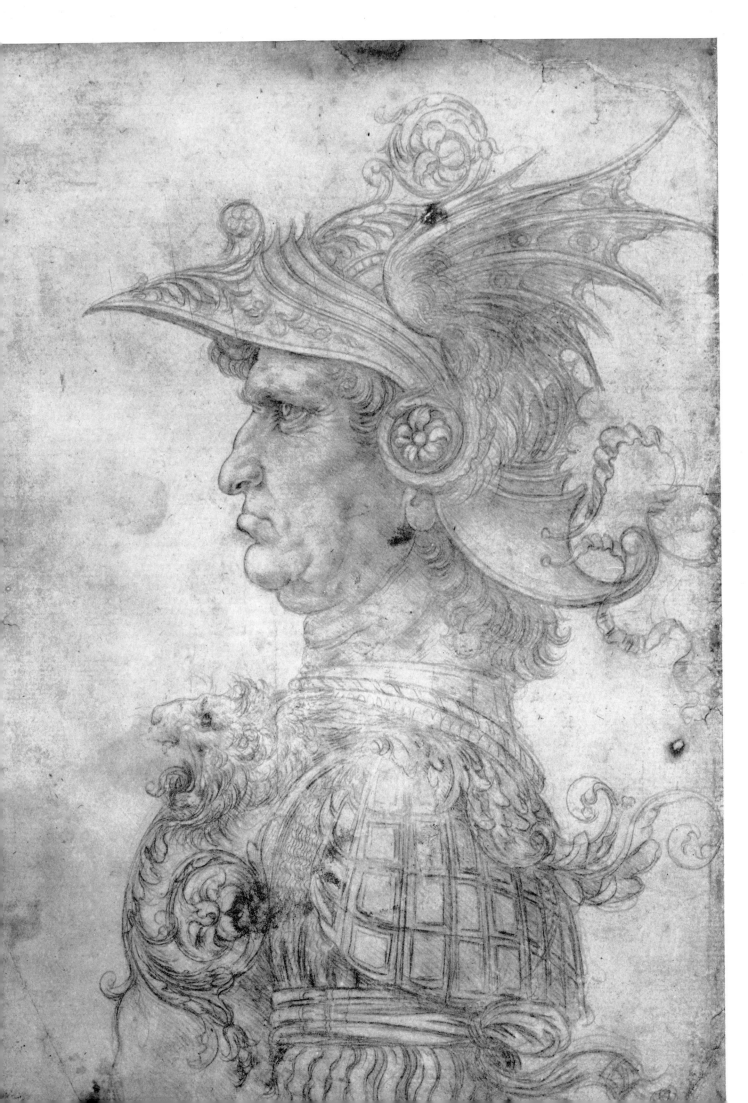

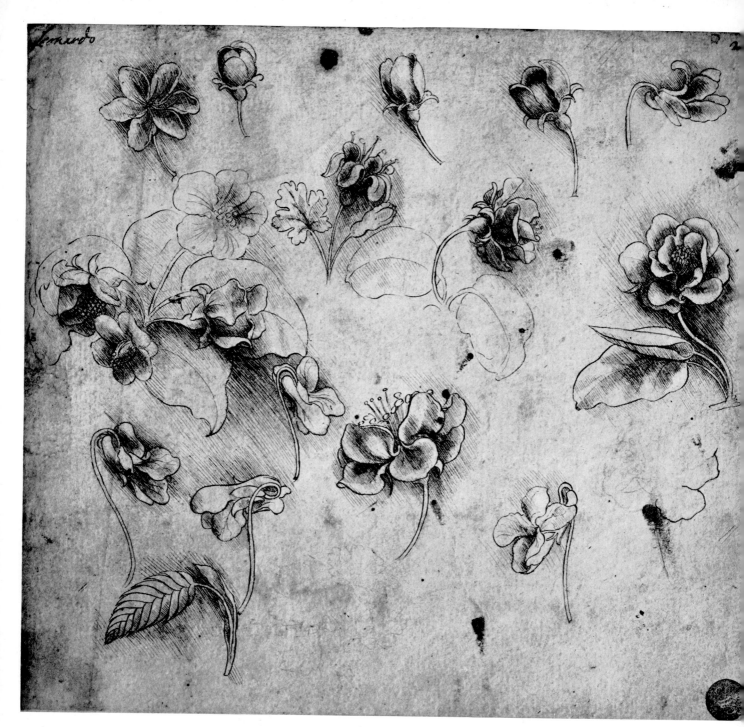

36. *VIOLETS AND OTHER FLOWERS.* About 1483. Pen over metalpoint. Venice, Academy

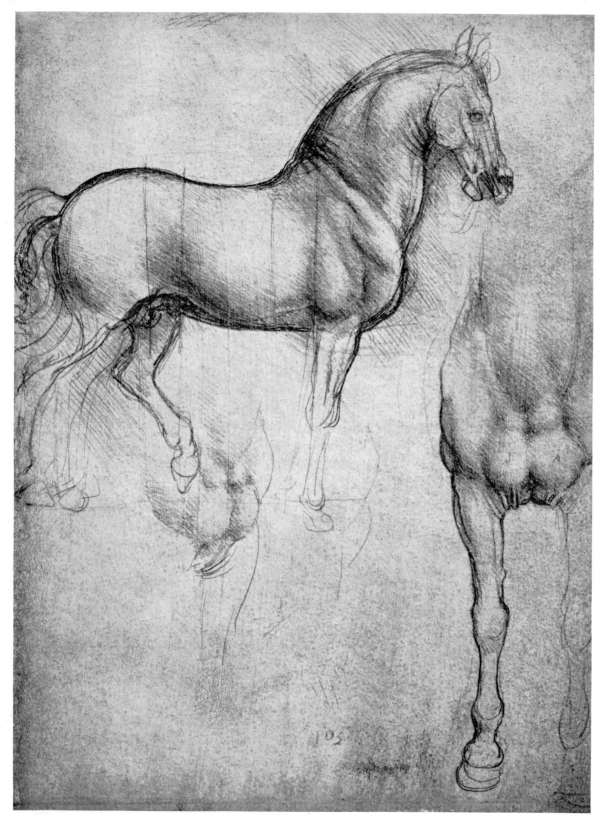

38. *STUDIES FOR AN EQUESTRIAN MONUMENT TO FRANCESCO SFORZA.*
1490–1. Silverpoint on blue prepared paper. Windsor Castle, Royal Library

39. *FIVE GROTESQUE HEADS.* About 1494. Pen on white paper.
Windsor Castle, Royal Library

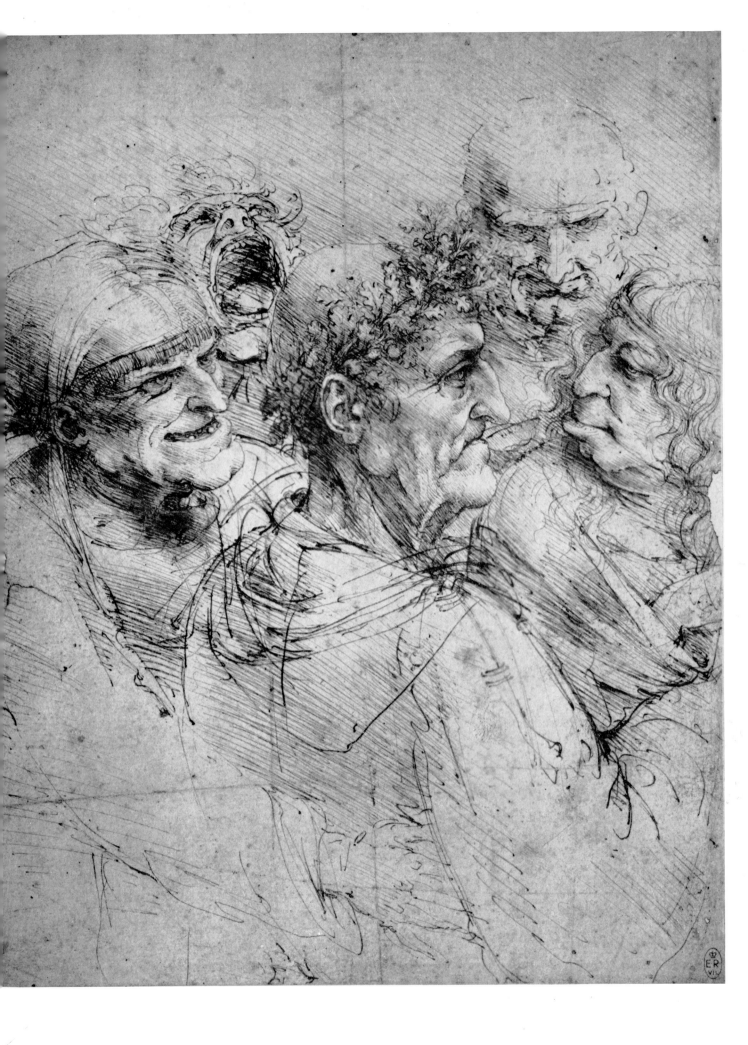

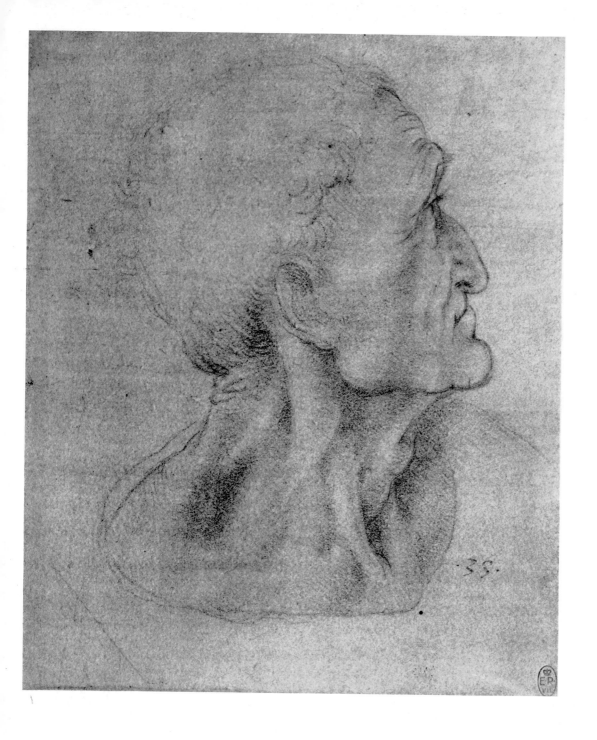

40. *HEAD OF JUDAS*. About 1495–7. Red chalk on red paper.
 Windsor Castle, Royal Library

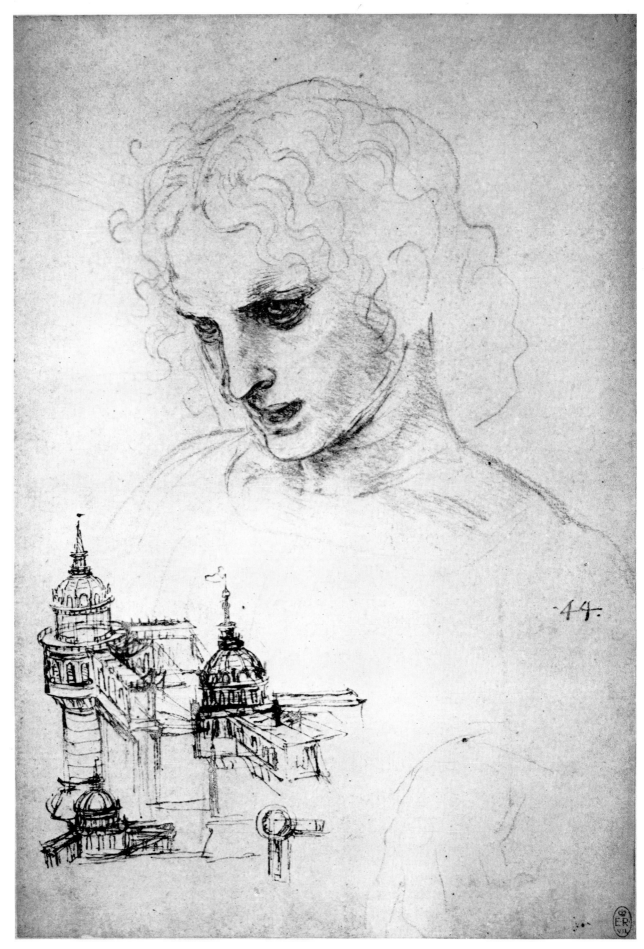

41. *HEAD OF ST. JAMES THE GREATER, AND A SKETCH OF ARCHITECTURE.*
About 1495–7. Red chalk and pen on white paper. Windsor Castle, Royal Library

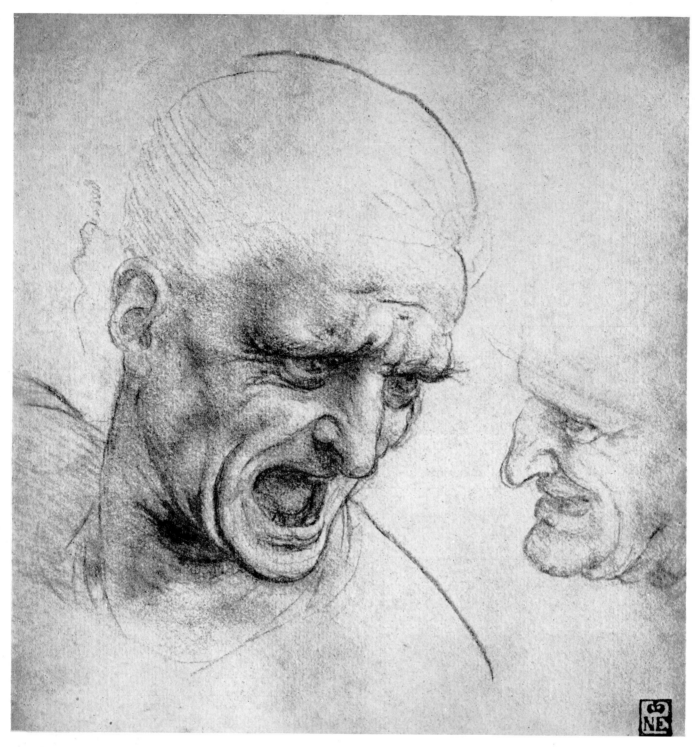

42. *HEADS OF TWO MEN.* About 1503–4. Black and red chalk. Budapest, Museum of Fine Arts

43. *STUDIES FOR AN EQUESTRIAN MONUMENT TO MARSHAL TRIVULZIO.* 1508–11.
Pen and bistre on greyish paper. Windsor Castle, Royal Library

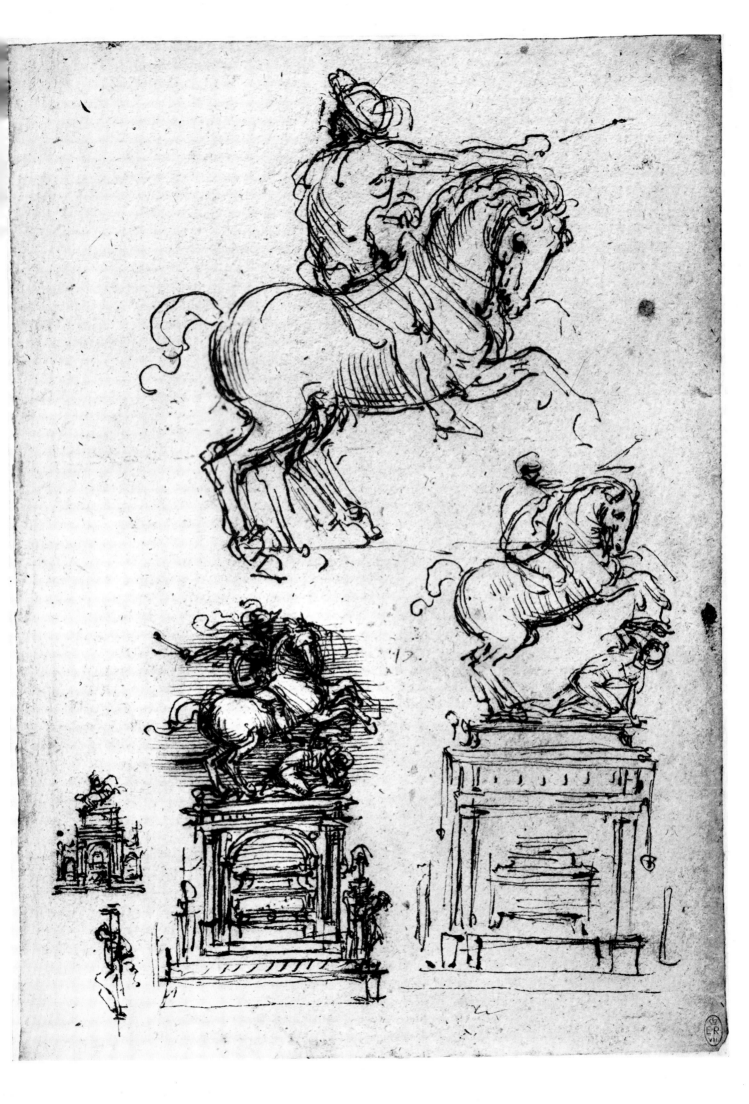

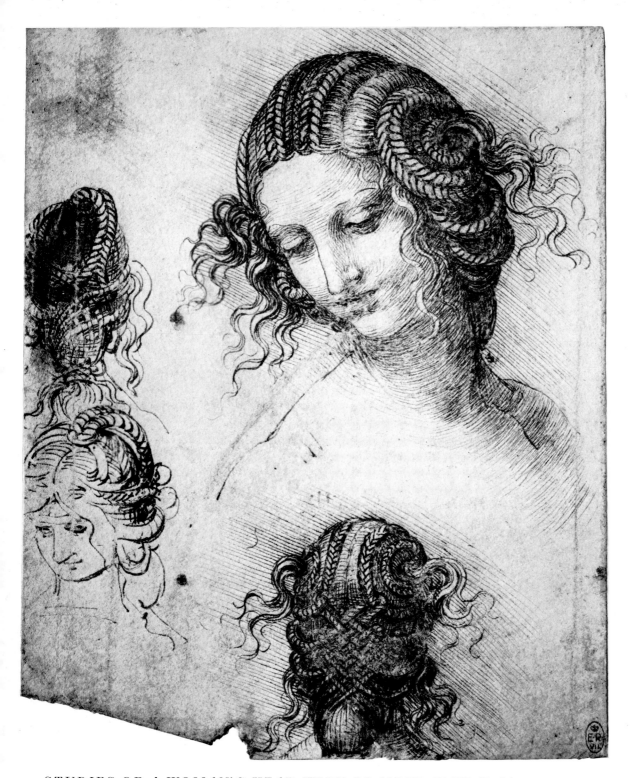

44. *STUDIES OF A WOMAN'S HEAD WITH BRAIDED HAIR* (Leda). 1509–10.
Pen over black chalk on white paper. Windsor Castle, Royal Library

45. *SKETCHES OF CATS*. 1513–14. Pen over black chalk on white paper.
Windsor Castle, Royal Library

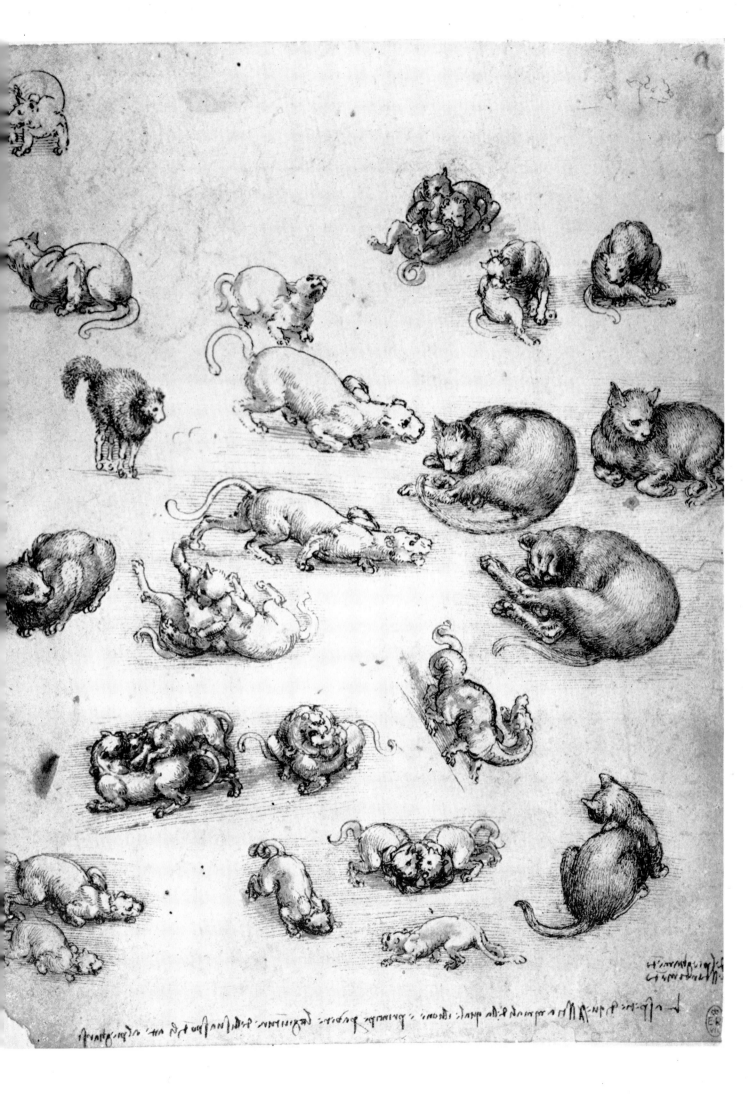

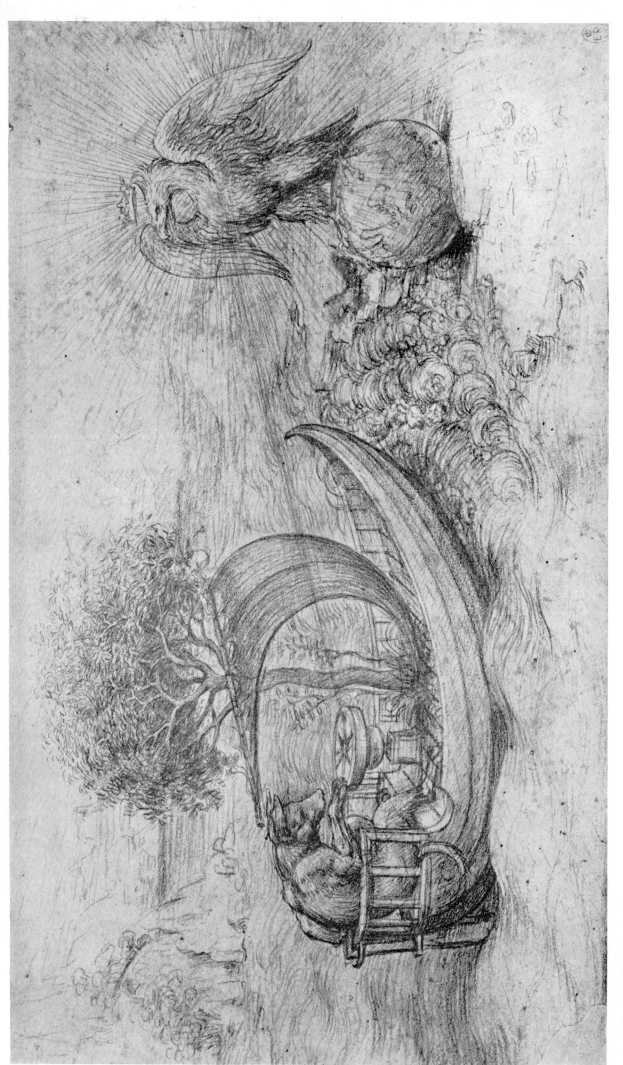

46. *AN ALLEGORY*. About 1513. Red chalk on brownish-grey paper. Windsor Castle, Royal Library

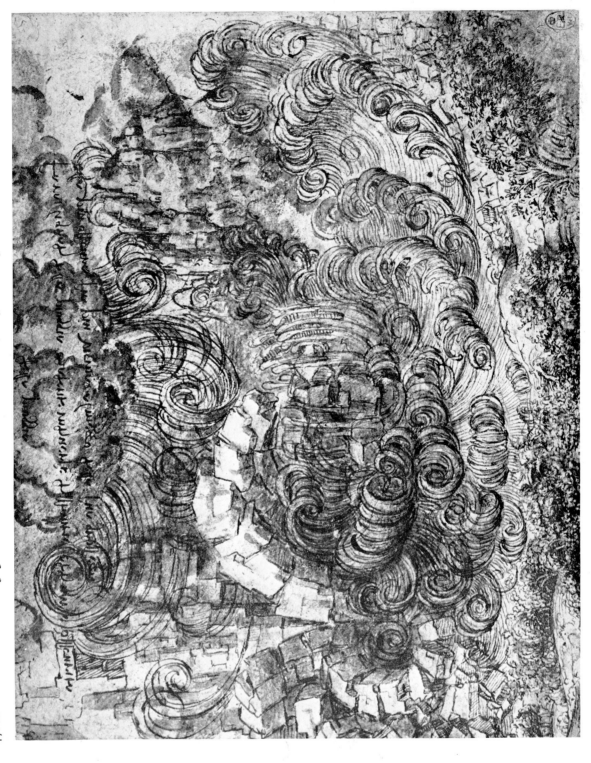

47. *A DELUGE*. About 1515. Black chalk and ink. Windsor Castle, Royal Library

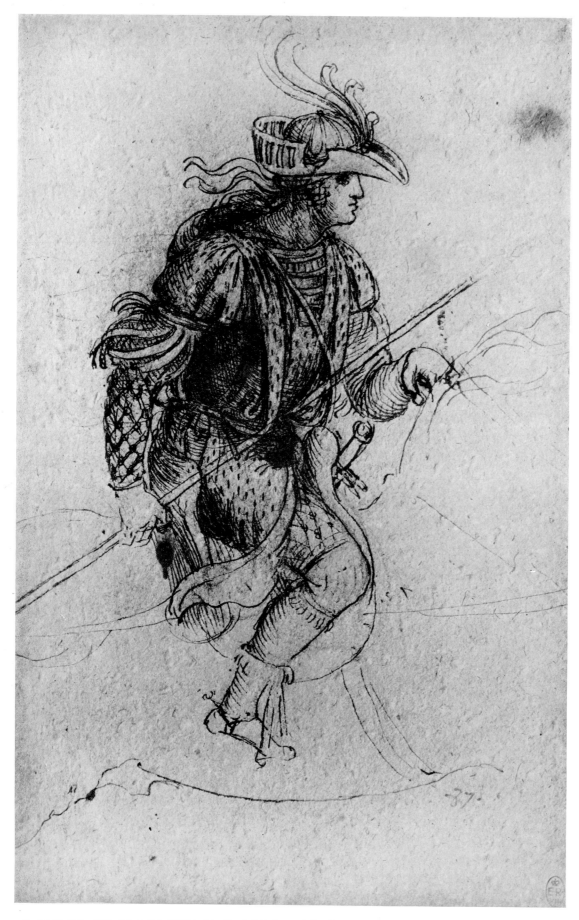

48. *RIDER IN MASQUERADE COSTUME.* About 1515. Pen over black chalk, on brownish paper. Windsor Castle, Royal Library